A MAN
AND HIS ART

A MAN AND HIS ART
FRANK SINATRA

Introduction by Tina Sinatra

Random House New York

Library of Congress Cataloging-in-Publication Data

Sinatra, Frank.
A man and his art / by Frank Sinatra : introduction by Tina
Sinatra—1st ed.
p. cm.
ISBN 0-394-58297-7
1. Sinatra, Frank. I. Title.
ND237.S5545A4 1991
759.13–dc20 90-53131

Printed and bound in Italy by Amilcare Pizzi S.p.A.
24689753
First Edition

For Dolly and Marty

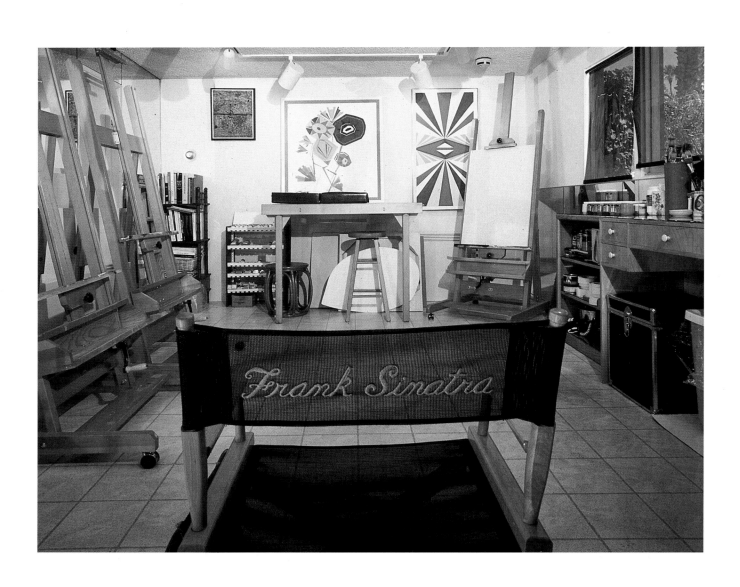

Introduction by Tina Sinatra

AS far back as I can remember, my father had a wonderful box of oil paints. It was a large, flat wooden box. Pine-colored. When you opened it, there was the unmistakable scent of the oil paints in spattered, crinkled-up tubes. I was always getting into them as a kid, opening them up, smelling them, touching the paint.

I'll never forget one day when I was about nine years old. We were all in Palm Springs. It was a torrentially rainy Easter weekend. I had a friend with me, and we were all stuck inside with nothing to do. My father went into a closet and pulled down some canvases and easels and the box of paints, and he said, "I've got a surprise for you." He spread out a big sheet on the kitchen floor and said, "Keep your colors separate, but here, I'll show you how to mix them." He started to paint with us and before we knew it a whole day had gone.

When I walk into my father's studio today, there is that same smell of oil paints, and I'm back in Palm Springs on that rainy Easter weekend. Oil paints and Yardley English Lavender—those are the smells that remind me of Poppa.

Once I said to him, "If you had to be blind or deaf, which would you take?" He said deaf. "I would hate to live in darkness," he said. "I can remember what things sound like, but I would hate to have to remember a sunrise or a wave hitting the shore." He was emphatic about it.

My father is very sensitive to light and shadow and color. To him, colors enhance life. He loves bright colors. Orange is his favorite, but he loves red too—the colors of the desert. You can see them in his paintings. A lot of his work has the essence of the desert, where he's lived for forty years.

Dad is affected by the shadows thrown at different times of the day. He is melancholy at dusk. He loves dawn. He feels reborn in the morning light. I can remember as a child being with him—he was always looking at the sky. He would look at a leaf, a simple leaf, and see the beauty of it, the color of it, the shadow it made when a breeze blew it. When I rode in a car with him, he'd say in the most dreamy way, "The sun is warm on my shoulder and my arm, but when I look through the window I can see the shadows of winter." He would point to a specific tree and expound on shadows and how they are thrown differently in the seasons. Some kind of curve or shadow would remind him of his past and take him back.

He also has a very keen sense of form. When he was young he wanted to be an engineer. He wanted to build bridges. He is moved by the shapes of things. If he walks up to a bronze sculpture, he'll touch it. It's automatic. He doesn't like those hands-off signs in museums.

Nobody ever taught Dad how to paint—though he did take some lessons from time to time. It's a part of him, not something he acquired. He was always curious, and one day he just decided to try it. Dad is the kind of person who will always say, "I can do that," or "I'd like to try that," or "I can do better than that." He's still the little boy who sat in his room after school and listened to music when the other kids were out playing stickball. Somewhere, sometime, something about painting struck him. I think it's the artist in him.

People like my father are always looking for ways to express their creative force. They find windows in their own souls through which they can shed their light. That force has got to come out, and painting is one outlet. I don't think anybody can have as much talent as my father and not have several forms of expression. That kind of talent is like a constant flame.

For Dad, painting is an artistic release that doesn't take a toll on his body and his throat and his mind. It doesn't tax him the way singing does. It takes a lot to maintain the energy, the stamina needed to get on and off airplanes and on and off the stage. He's still doing what he was doing fifty years ago. The experience of performing is exhilarating, but he uses his painting to unwind and recharge. It takes days to come down from being on the road and then to prepare to go out and do it again. Painting is a refuge for my father. It's something he can do in a room by himself. Dad loves that aloneness and that oneness. It's soothing and restful and therapeutic for him. It restores him. It's not as though a celebrity of his renown can just go out and take a walk. He gets mobbed. He has to go where he can be alone.

Painting distracts him. He gets very absorbed in it. When he's working, I could walk in the room and say, "Hi, Dad, I just shot a man in the foot, stole his car, and beat up his wife," and he'd say, "Oh, fine." His studio isn't a place where people normally visit him. He has a phone but it doesn't ring in—he can make calls, but he can't get them. Sometimes he calls me from the studio. I say, "What are you doing?" He says, "Just fooling around on a painting. I had to stop to talk." He usually listens to classical music while he paints, or a ballgame, or maybe the news. He says he sometimes gets up in the middle of the night with a thought or a vision and goes in to paint.

Painting is a passion. There are periods when he's in the studio for days. Day upon day upon day—it's just what he's in the mood to do, what he needs to do. I imagine that for Dad, who has lost so many good friends, painting has become an old friend.

Dad is very visual. He uses his eyes the way he uses his throat. Again and again, people ask me what makes my father such a special singer. It's his interpretation of the lyrics, the way he emotionalizes and internalizes what he is singing. Rodgers and Hart wrote "The Lady Is a Tramp," but Poppa made it his own. That's how he paints. Dad is an interpreter, a stylist. He sees a painting by Kelly or Motherwell or Kline, and he gets it in his head and wants to reinvent it for himself. A few years ago I walked into his studio and saw a painting that reminded me of Mark Rothko's work, which I could never afford, and I jokingly said, "That's great. So now do a Rothko for me." He laughed.

Dad's the first to say, "Oh, I saw this painting in a museum," or "I was looking at an art auction catalogue," or "I remember this painting from somebody's house twenty years ago, and I've never forgotten it." He's the first to admit that he tends to mimic what he's seen, but, just as with music, it becomes Frank Sinatra's because he stylizes it. He never copies, he re-creates. He takes a form that has been locked in his memory, that pleases him, and he reinterprets it. He's got a very good memory and the eye of his memory seldom fails him. He plucks an image from his mind and puts it on canvas the way he wants to see it. His work is always interpretive, never imitative. Dad says if he had studied painting more he could be much better at it, but I think it's fine. It's so purely Frank—it's *uniquely* Frank.

You can track Frank Sinatra's emotional life through his music. If he was unhappy during the breakup of a relationship, he was not making songs for swinging lovers. He was making "No One Cares" or "In the Wee Small Hours of the Morning." You can hear the difference. I believe he always wanted to express what he was feeling at the time. He would not let his music belie his feelings. This is true about his painting, too. You can see when he is melancholy. He has a lot of sadness in him, a lot of hurt. His first paintings were of sad-faced clowns. (Some of them are actually self-portraits.) But he can surprise you, too. Once he did a painting of mountains, and if you look carefully enough, you realize it is the San Gorgonio mountain range, the place where my grandmother's plane crashed. He painted it in bright colors, with a fire in the sky. He didn't paint it ruthless and dark and cold and snowy and bleak and awesome and ugly, the way it looked the day he lost his mother. He painted it much more gently. It was a catharsis for him.

Like most artists, Dad's moody. He's said that he likes to get his paintings finished quickly because his mood begins to change. He's got his attention directed at the canvas for a period of time, and then he wants to move on to the next one. His paintings can be whimsical and funny.

I remember him always doodling. He's wrecked tablecloths in some of the finest restaurants in the world—like the doodles he made at dawn on two paper napkins in a sidewalk café in Monte Carlo in 1971. He took his black felt-tip pen and absent-

mindedly drew these funny little faces. I carried them with me around Europe for weeks. Now they're framed in lucite.

Dad paints feelings. He paints what moves him. He doesn't do anything without an emotional impetus. That's Frank. He was so moved by the accomplishments of the *Voyager* that he painted it. He loves trains—his paintings are full of them. He was raised in a neighborhood very near the tracks in Hoboken, and he grew up watching trains, jumping on and off of them. He used to get smacked upside his head for that because it was dangerous. Trains, he says, were a way out. There is still a train set around his Christmas tree every year, and he has a wonderful room in his house dedicated to his train collection. His trains are from all over the world, old and new. People know what presents to get for him: You buy Frank Sinatra trains or you buy him oil paints.

Dad paints what he likes. He doesn't do it to please anybody, yet you can commission him. You can say, "I need a canvas five feet by five feet," and he'll do it. He's not like a drive-through burger joint, but he's quick about it. A few years ago, I moved to a new office, and I said, "Dad, I need art." He said, "What do you want?" I told him I needed several white-and-blacks or white-and-grays, about three feet by three feet. He went right to work and did these gorgeous paintings for me. Another time our lawyer happened to mention that he had an eight-by-ten-foot bare spot on his living room wall. Dad not only finished a painting for this guy in two weeks, he was right there in the house for the installation. One night we were standing in the foyer of Gregory Peck's house saying good night after a dinner party. Dad looked at the wall and said, "I am going to do a painting for you to hang right there," and he went home and painted it. When I saw it I realized that the pattern and color echoed almost exactly the tiled floor in the Pecks' hall.

For the past ten years or so my father has painted in a geometric abstract style, which has been very satisfying for him. He is a fastidious person, a detail man, so he relishes the precision required to paint severe forms. I remember one day being impressed by a two-toned canvas he was working on that had a remarkably straight line separating the two colors. I said, "Dad, you did that really well. It's like pinstriping on a car." He said, "You do it with tape. That's how it's done." He showed me how he did it. You literally put on the tape and pull it off. The technique thrilled him endlessly, and he played with it for weeks. He was so fascinated by it that he wanted to find out everything that could be done with that tape. When he discovers a design he likes, he paints it many times in different colors until he's through with it.

He isn't a quitter on canvas. Once I asked him, "Does it ever get hopeless? Do you ever have to throw out the canvas?" He said, "Sometimes when I can't take what I feel in my heart down from my hand onto the canvas, I'll just paint it white and go at

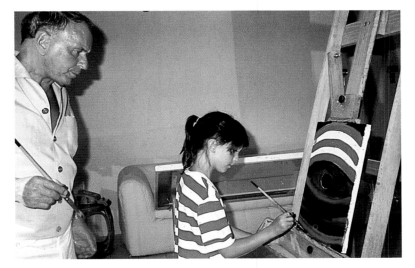

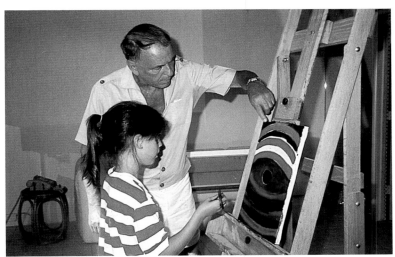

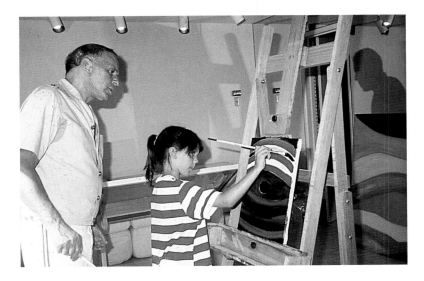

Frank Sinatra with granddaughter Amanda

it again." He told me that you can play with a painting—begin in one direction and finish in a whole other one. It's almost a stream of consciousness. Maybe that's why he enjoys working on large canvases—he can start small and end big and connect the wide expanse. That's the bridge builder in him.

For Frank Sinatra, painting isn't an intellectual pursuit—it's visceral. It's more intangible, more essential than that. This book is the essence of him. Painting is a part of his talent that not many have seen before. This book is a way for him to share a very personal side of himself. It's a little like publishing a book of poetry. It's another window into his soul.

A MAN
AND HIS ART

1985, Barbara Sinatra Children's Center, Eisenhower Medical Center,
Rancho Mirage, California

2

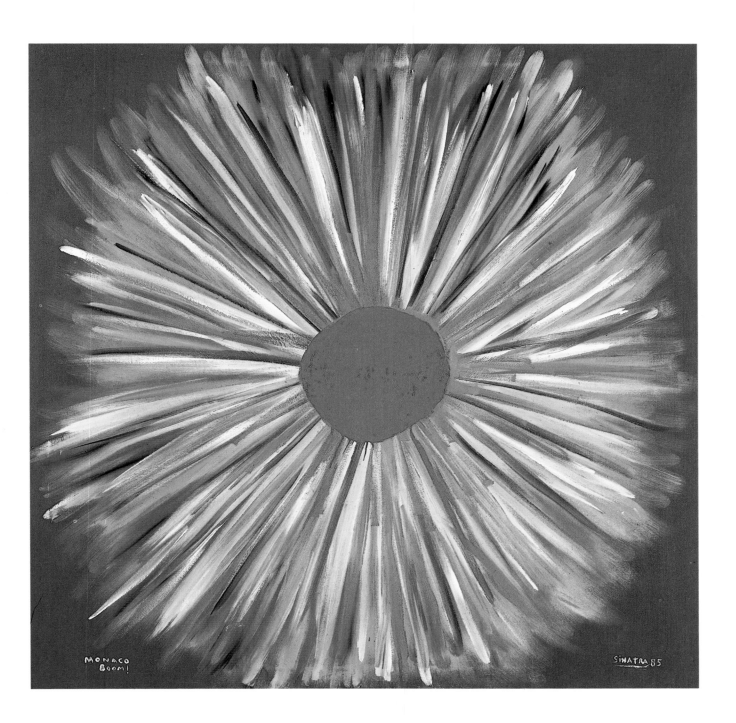

MONACO
BOOM!

SINATRA 85

1989, 20″ × 24″, collection of Frank Sinatra

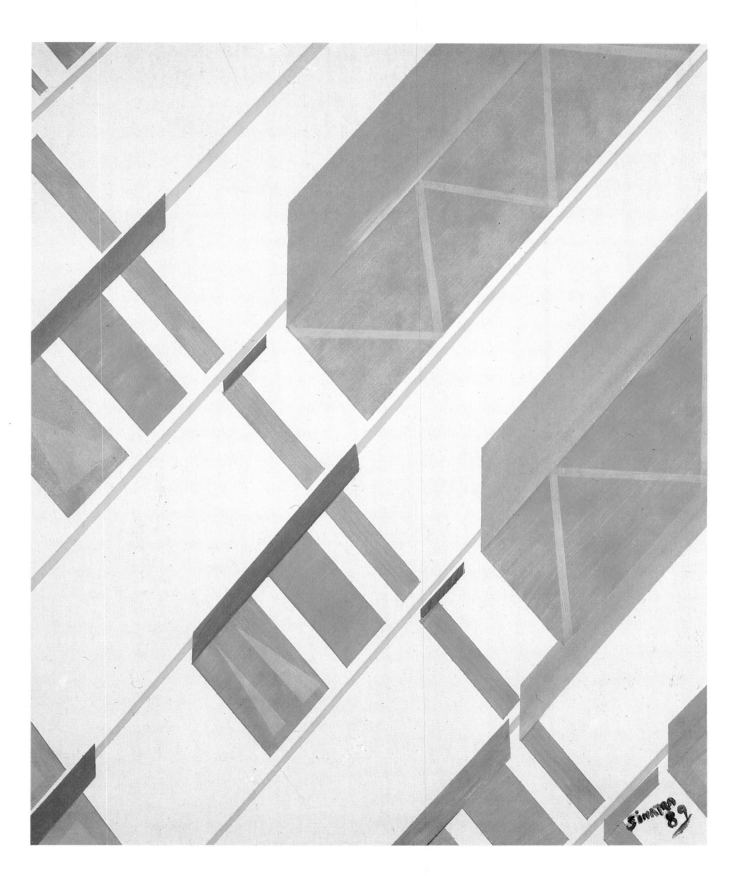

1989, 57″ × 47″, the Desert Hospital, Palm Springs, California

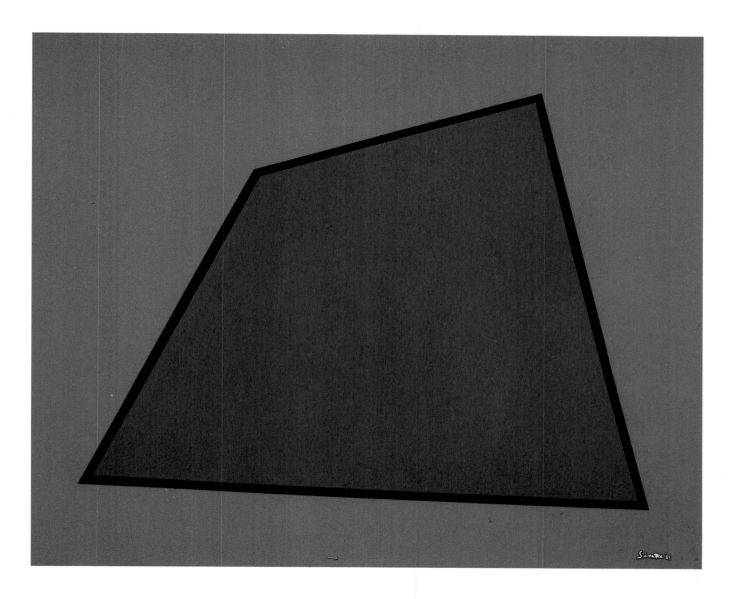

37″ × 50″, collection of Frank Sinatra

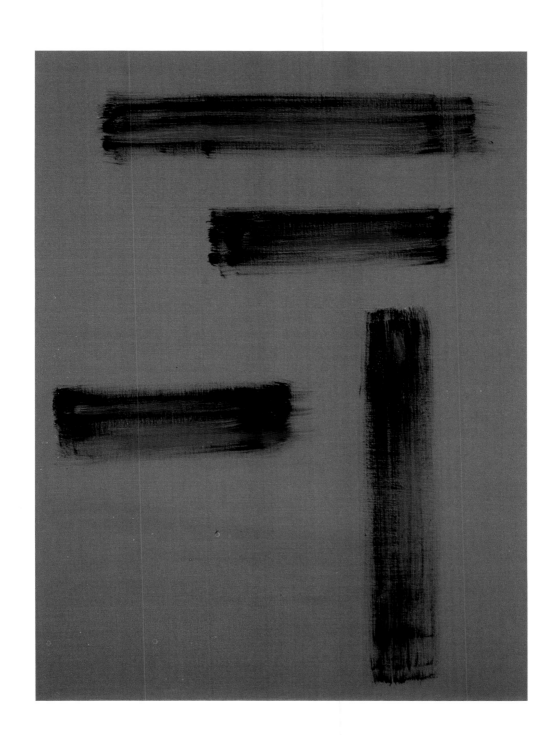

1988, 40″ × 36″, collection of Frank Sinatra

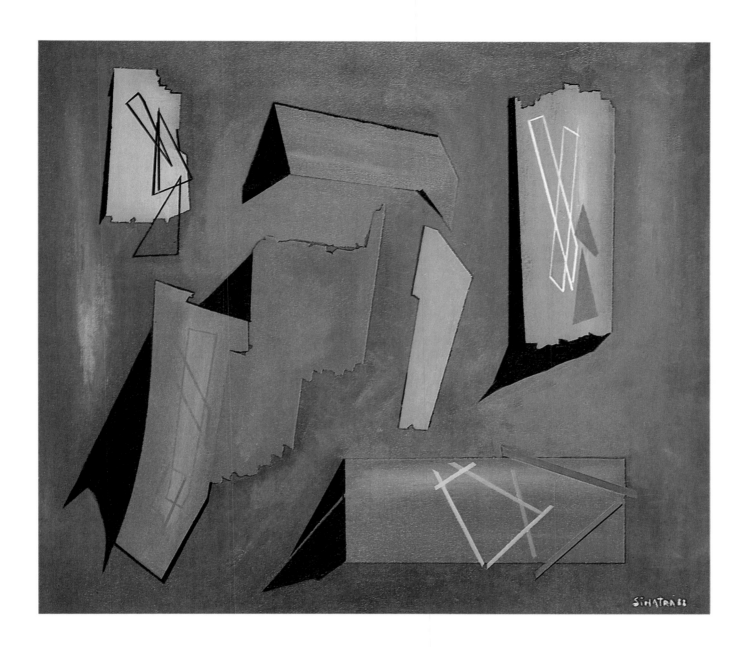

1988, 20″ × 30″, collection of Frank Sinatra

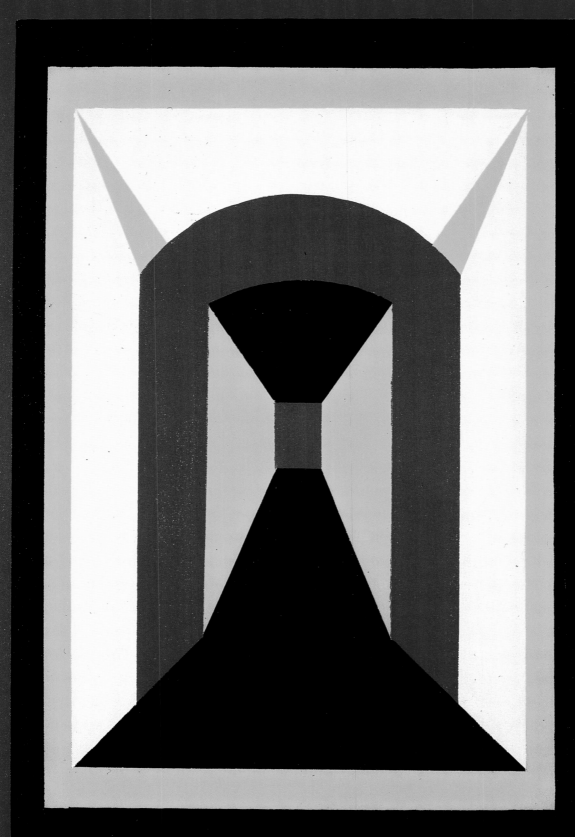

1984, 46″ × 47″, collection of Gregory and Veronique Peck

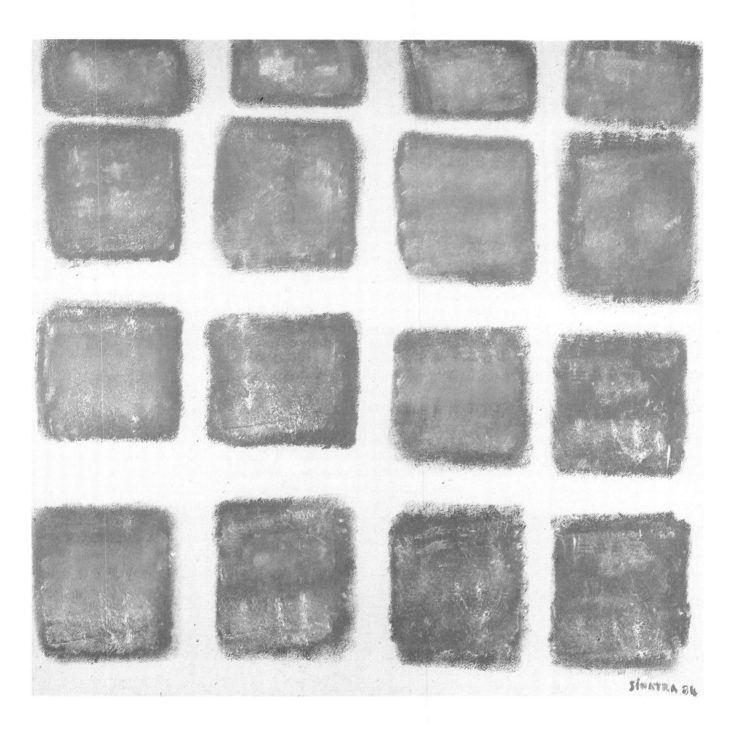

SINATRA 86

1984, 47″ × 23″, collection of Tina Sinatra

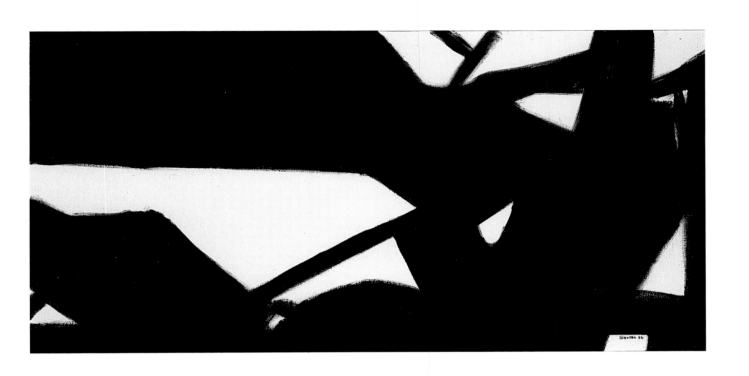

96″ × 96″, collection of Robert Finkelstein

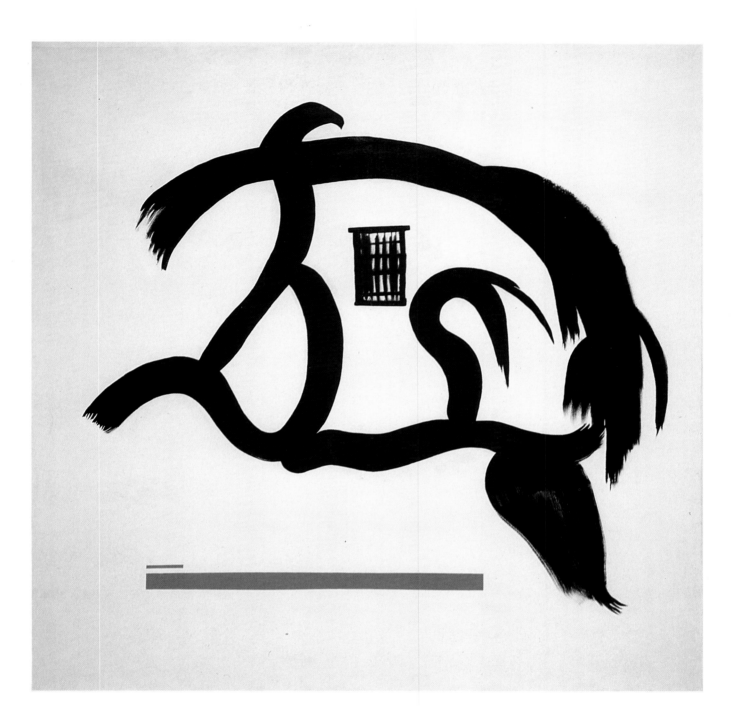

1987, 50″ × 60″, collection of Frank Sinatra

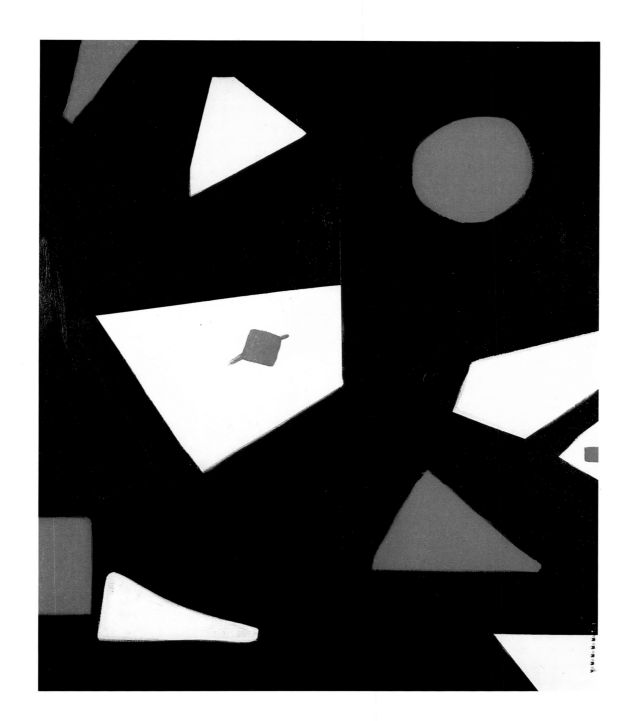

1984, 60″ × 48″, collection of Frank Sinatra

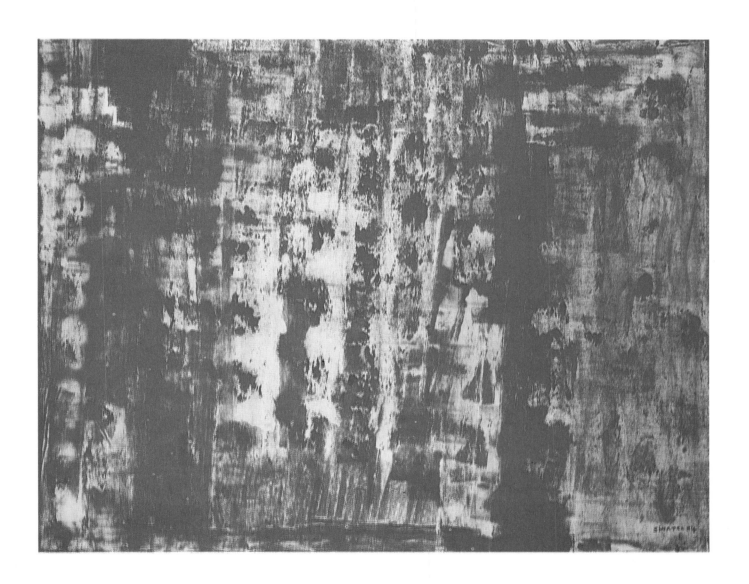

1983, 48″ × 36″ collection of Frank Sinatra

歡
迎
光
臨

SINATRA47

Collection of Ronald and Nancy Reagan

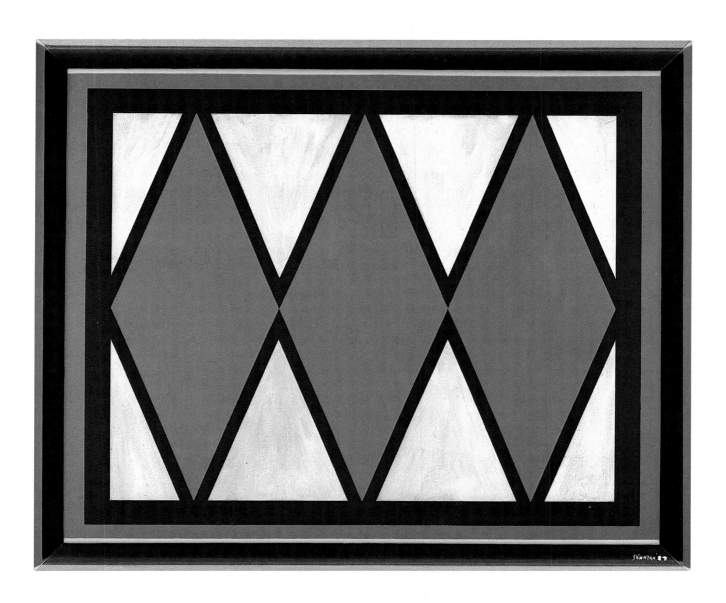

1985, 32″ × 36″, collection of Frank Sinatra

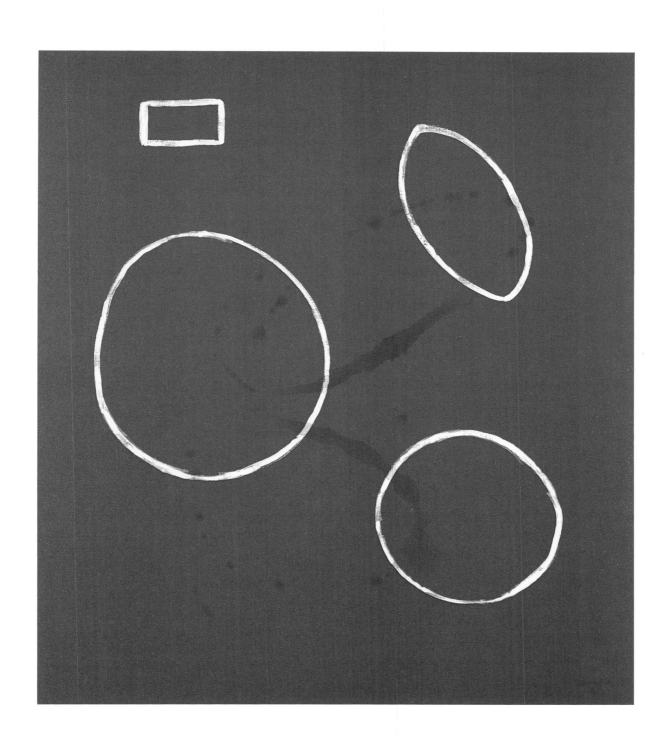

1986, 29″ × 29″, the Desert Hospital, Palm Springs, California

SINATRA 86

Collection of Tina Sinatra

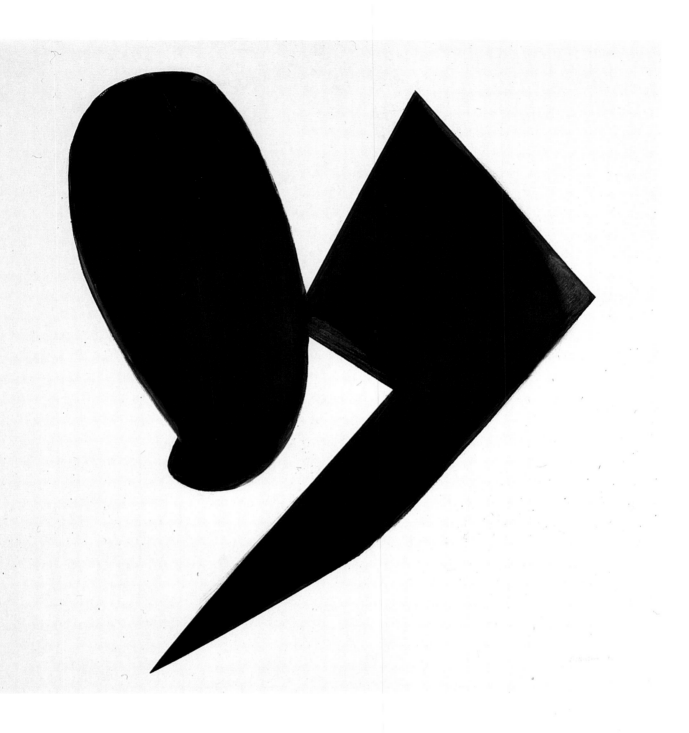

1989, 50″ × 42″, collection of Frank Sinatra

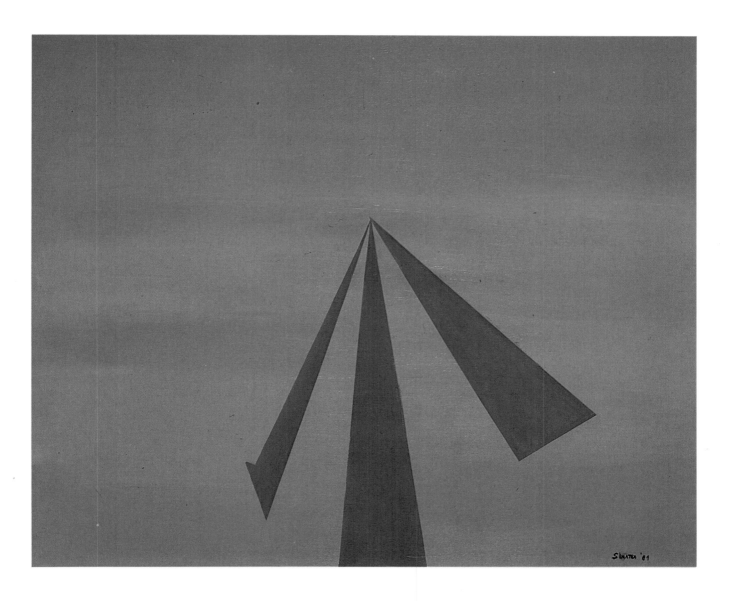

1989, 38″ × 42″ collection of Frank Sinatra

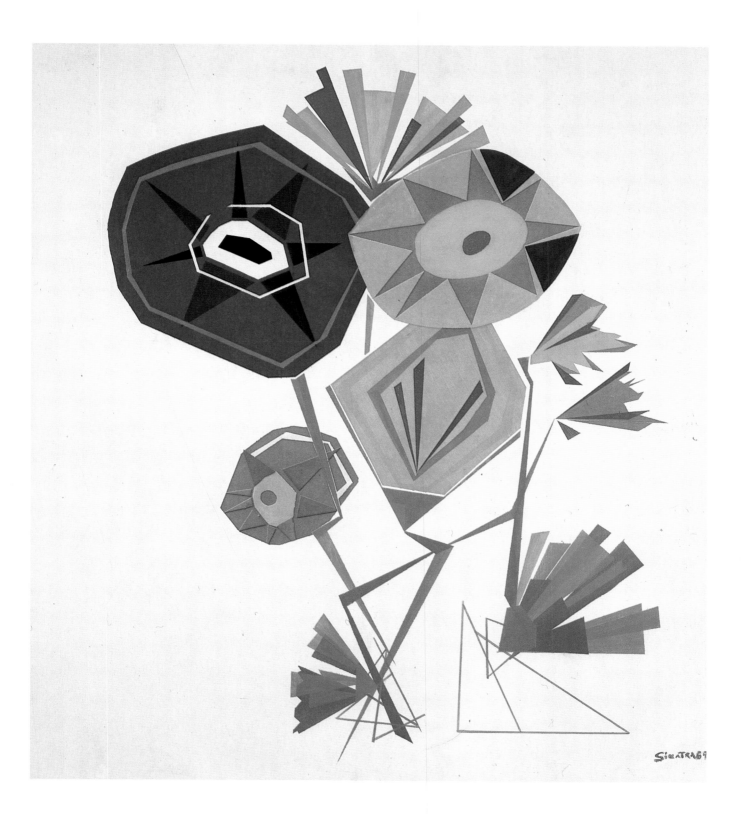

1988, 38″ × 26″, collection of Frank Sinatra

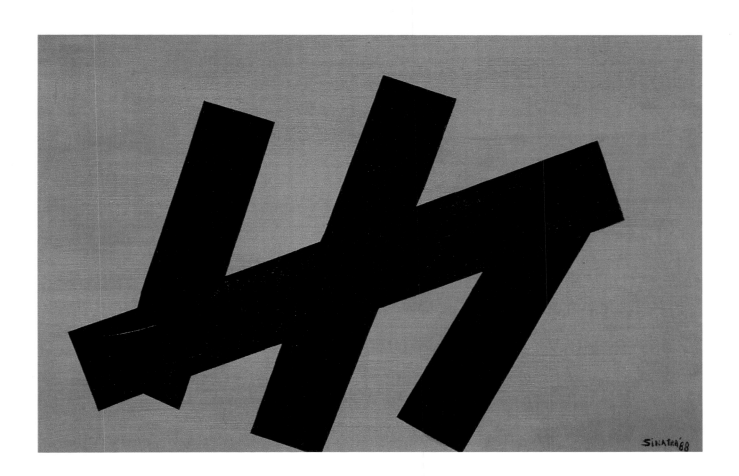

1989, 39″ × 39″, collection of Frank Sinatra

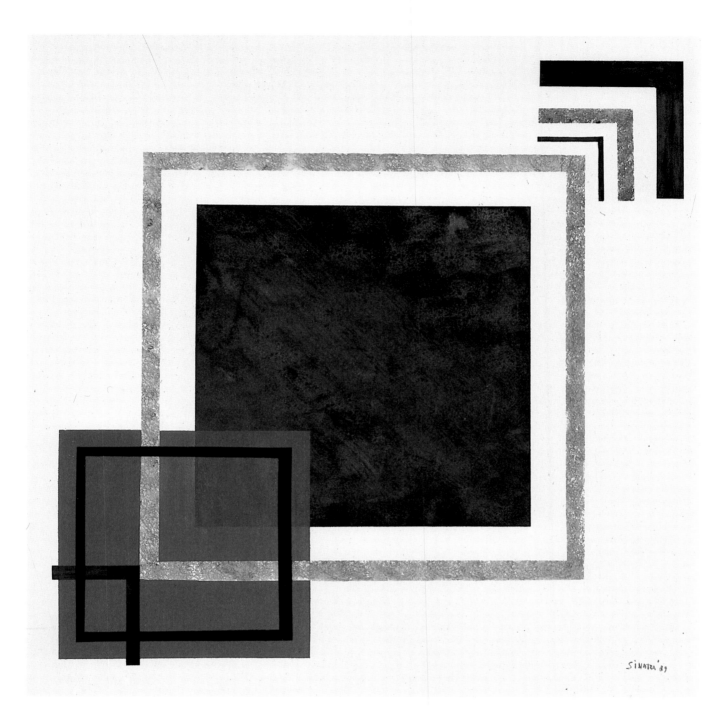

1985, 20″ × 16″, collection of Frank Sinatra

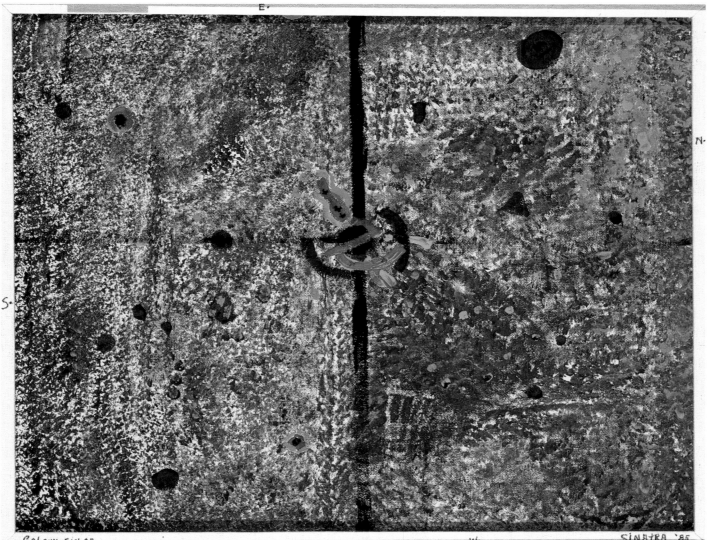

E.

N·

S·

GALAXY Sept.85 W· SINATRA '85

1987, 28″ × 38″, collection of Frank Sinatra

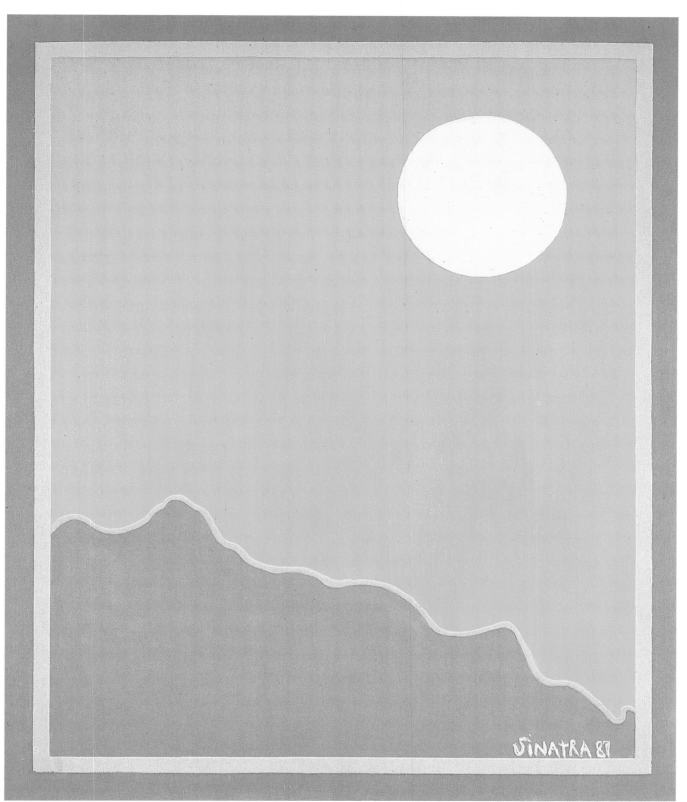

1987, 20″ × 30″, collection of Frank Sinatra

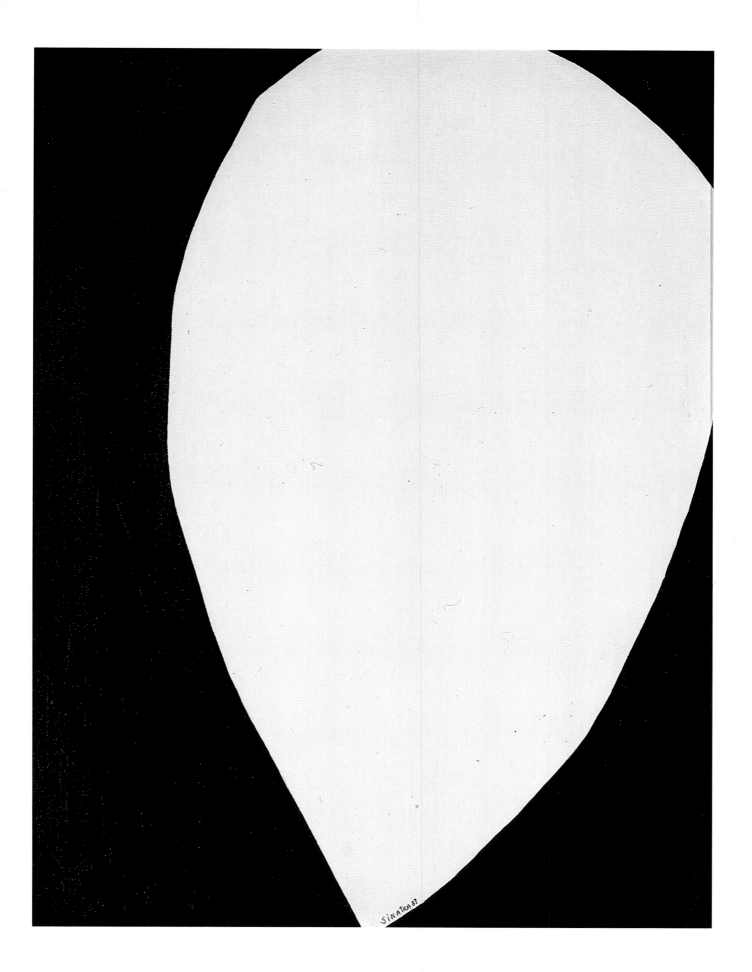

1987, 30″ × 40″, collection of Frank Sinatra

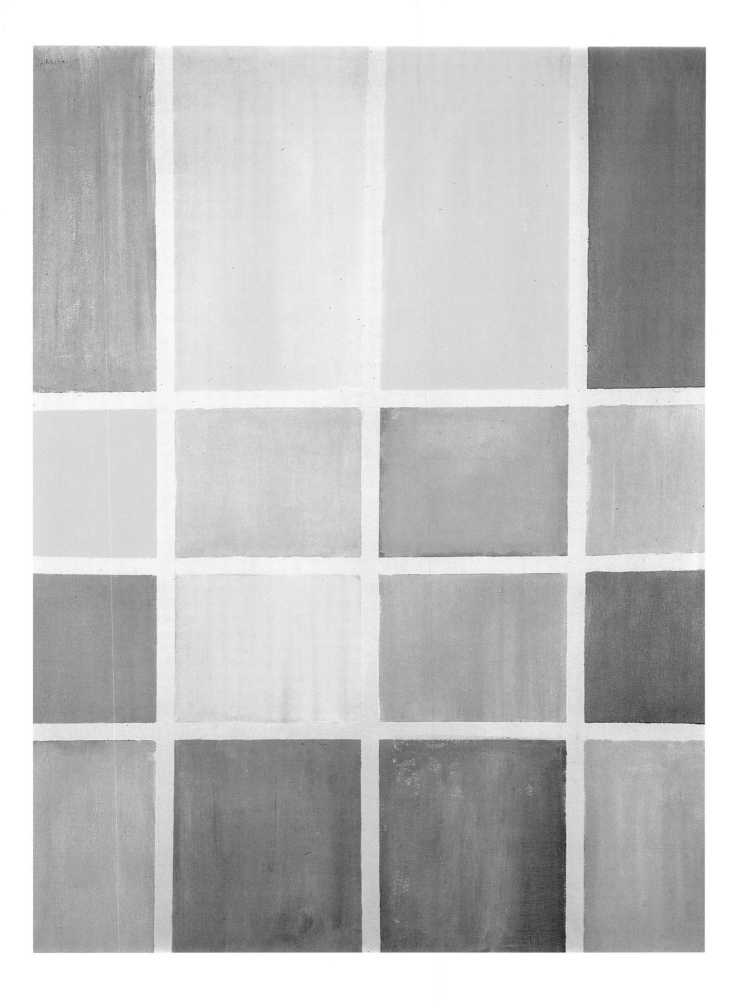

1987, 30″ × 30″, collection of Frank Sinatra

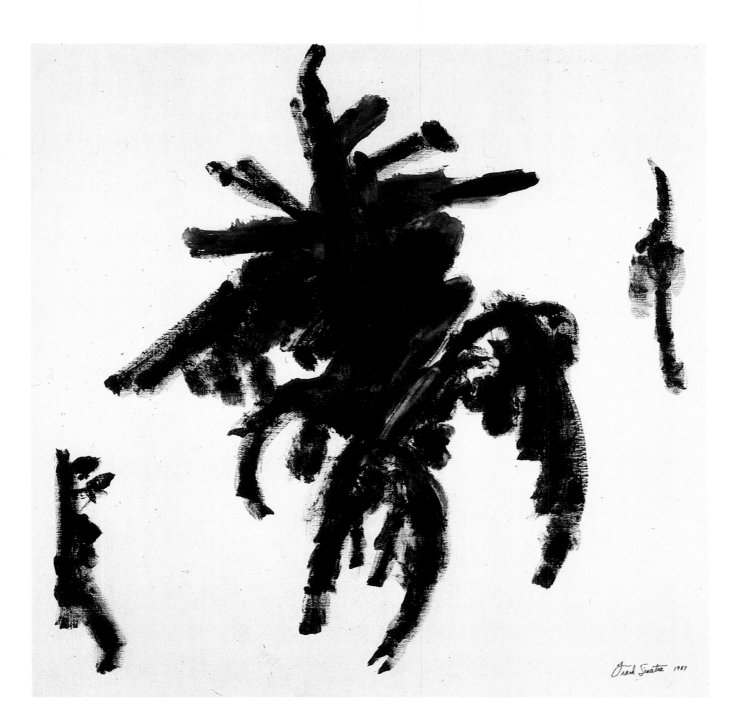

Frank Sinatra 1981

1988, 24″ × 18″, collection of Albertha Keith

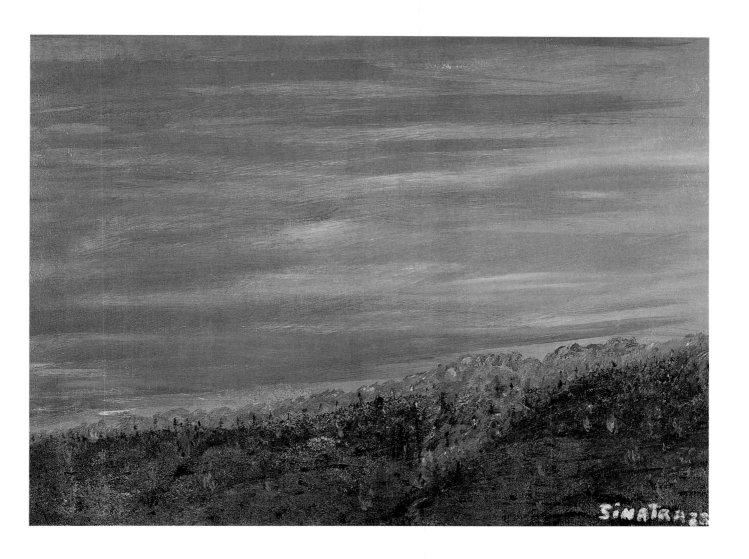

1987, 30″ × 36″, collection of Frank Sinatra

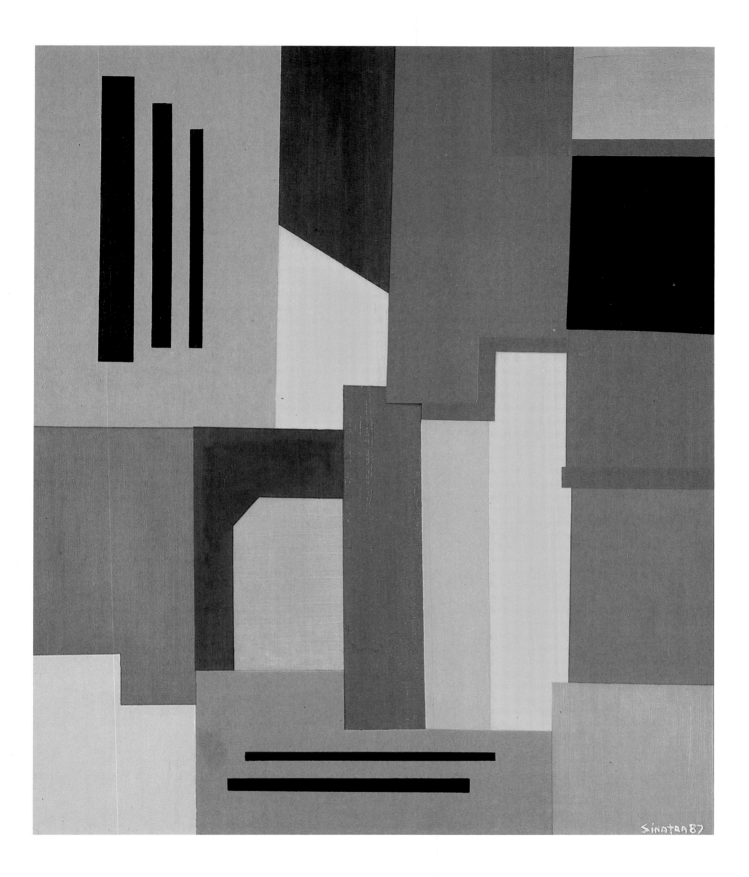

1987, 30″ × 30″, collection of Frank Sinatra

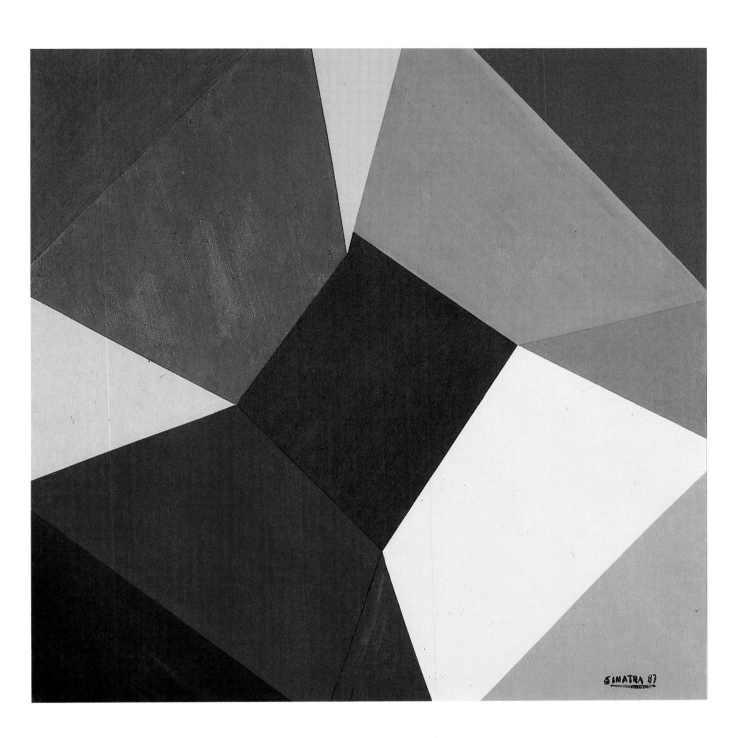

1985, 20″ × 45″, collection of Dr. John Lake

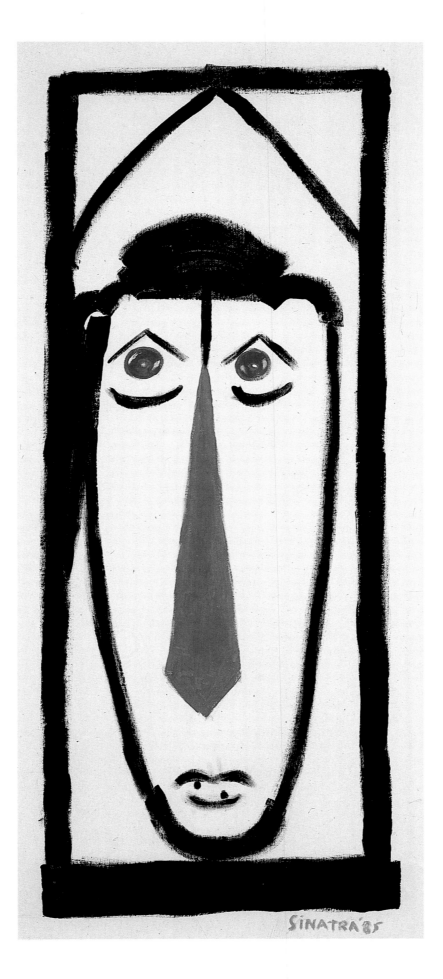

29" × 29", collection of Frank Sinatra

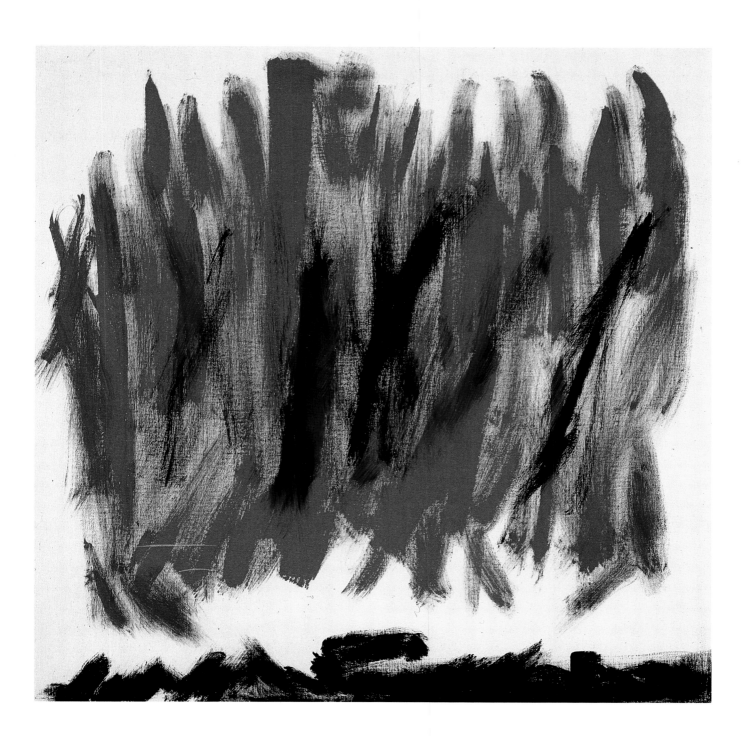

1983, 47″ × 47″, collection of Frank Sinatra

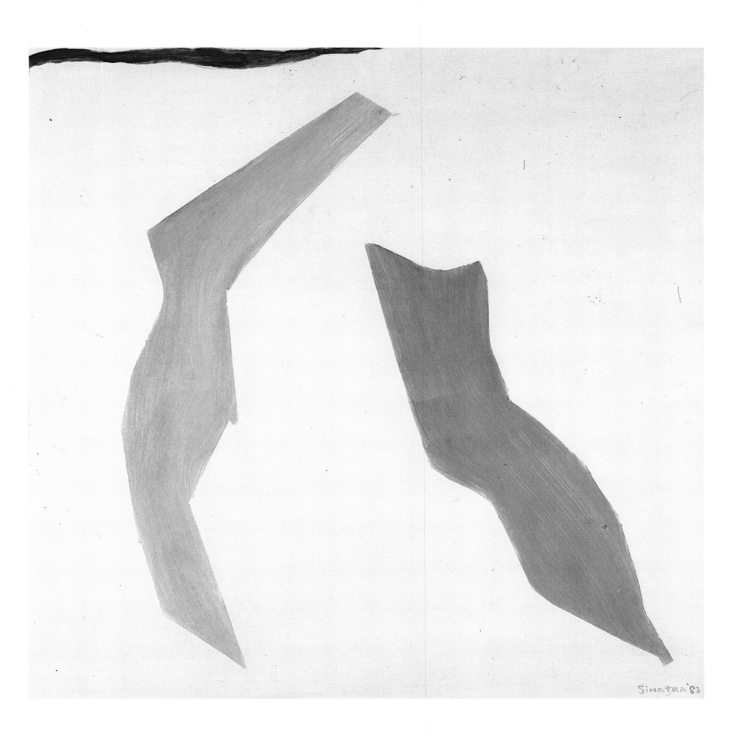

1985, 32″ × 42″, collection of Frank Sinatra

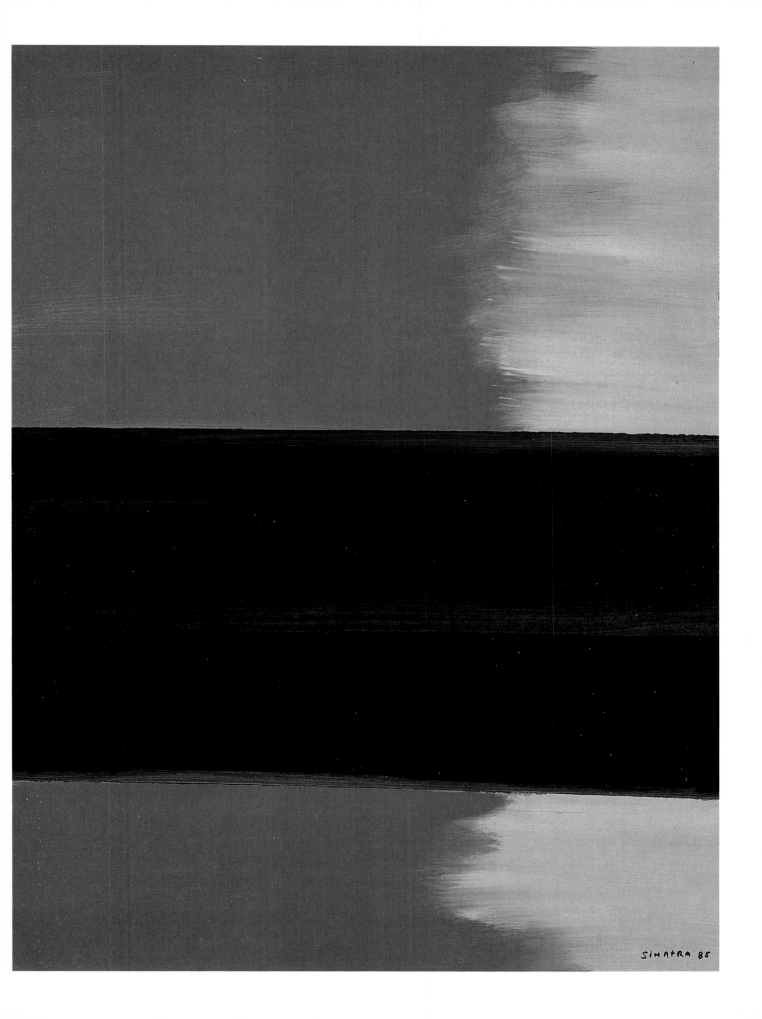

1987, 20″ × 30″, collection of Daniel Schwartz

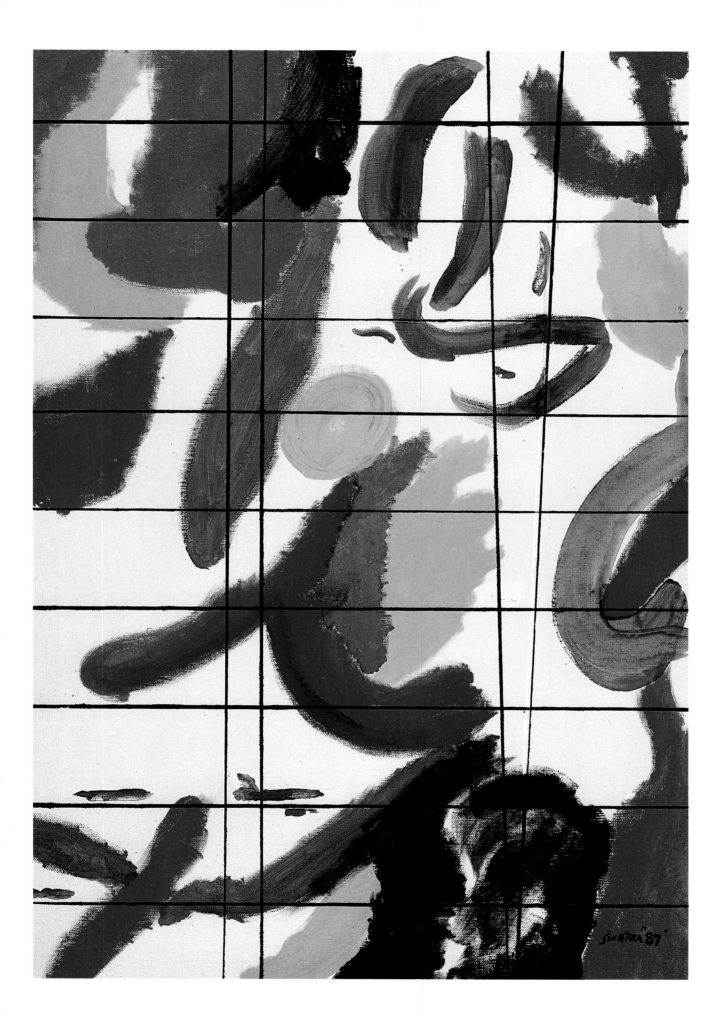

30″ × 40″, collection of Frank Sinatra

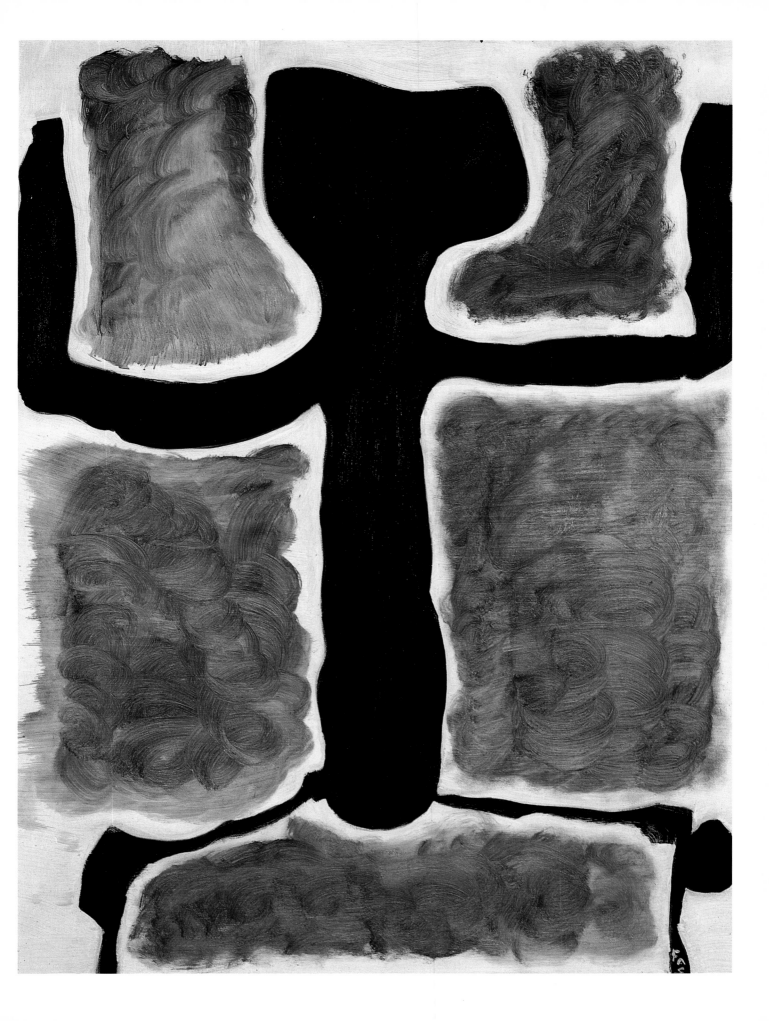

1985, 42″ × 26″, collection of Frank Sinatra

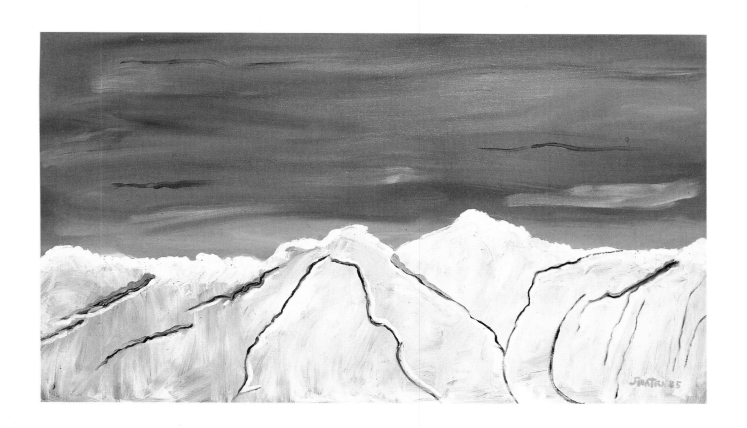

1989, 39″ × 47″, collection of Frank Sinatra

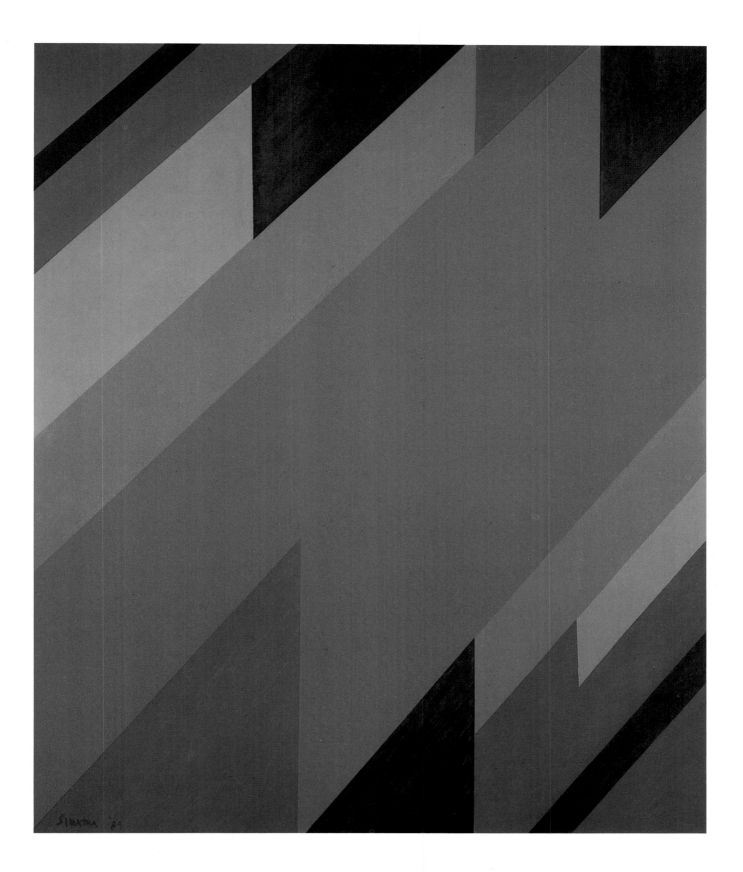

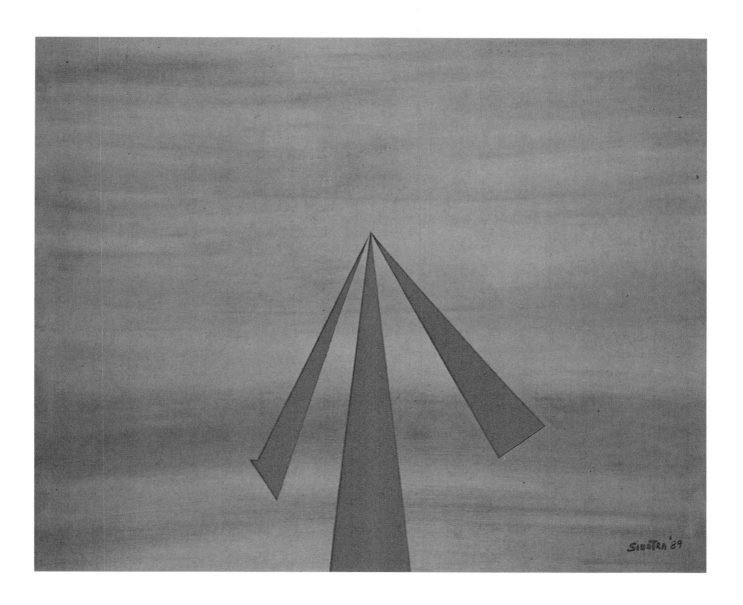

1986, collection of George and Jolene Schlatter

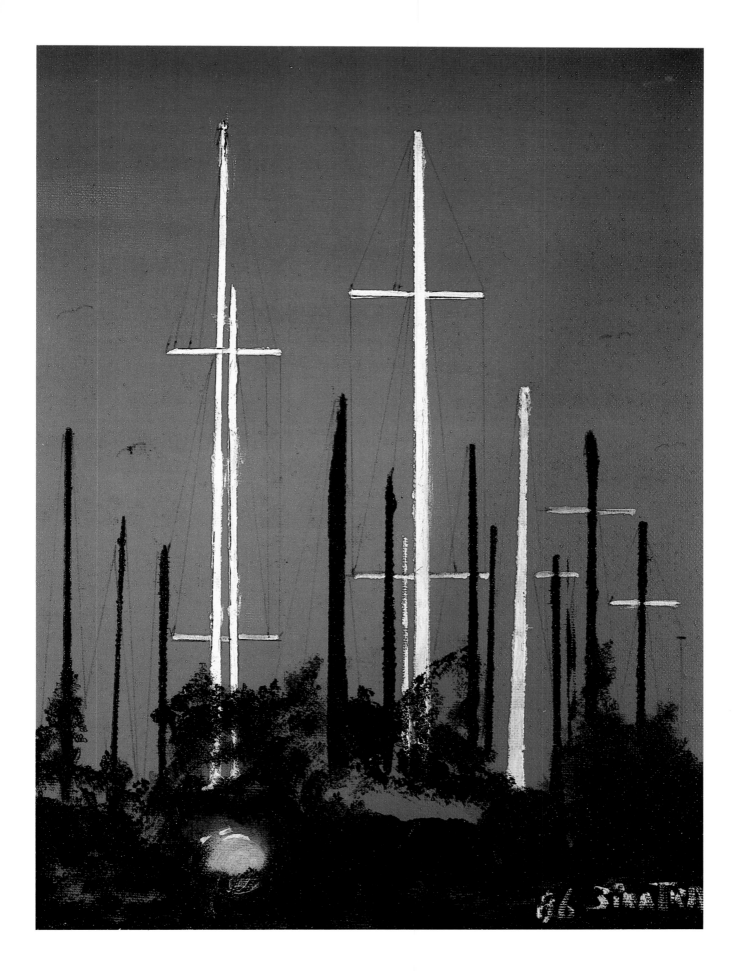

1983, 36″ × 24″, collection of Daniel Schwartz

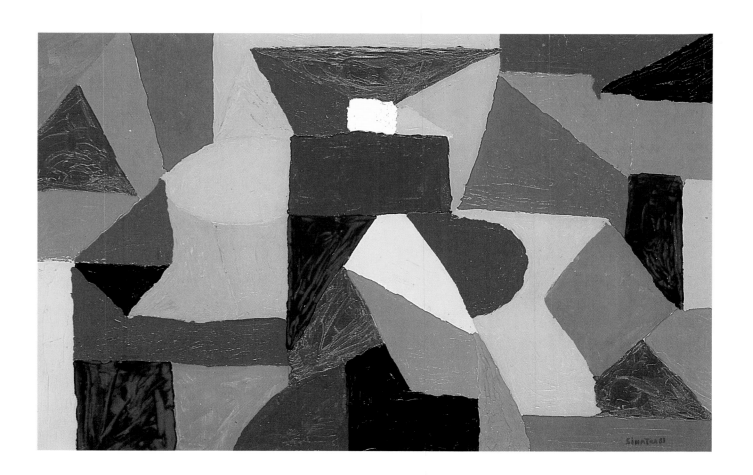

1987, 35″×29″

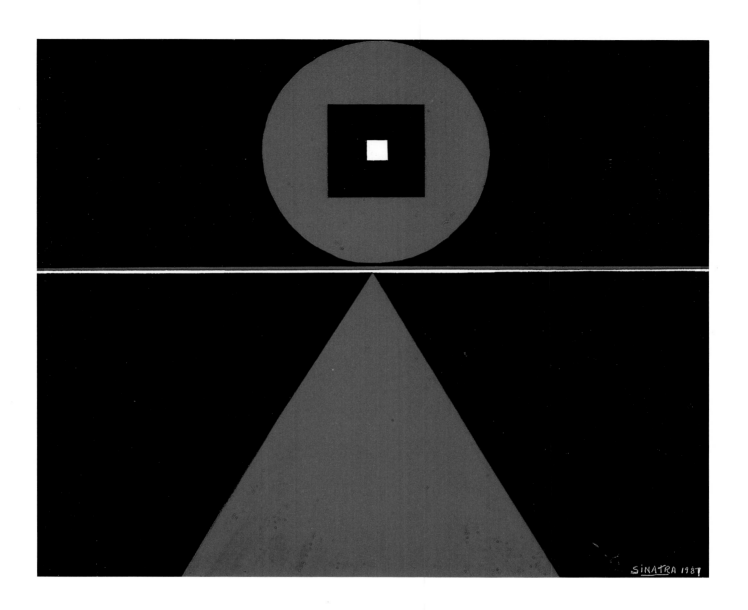

1989, 40″ × 46″, collection of Frank Sinatra

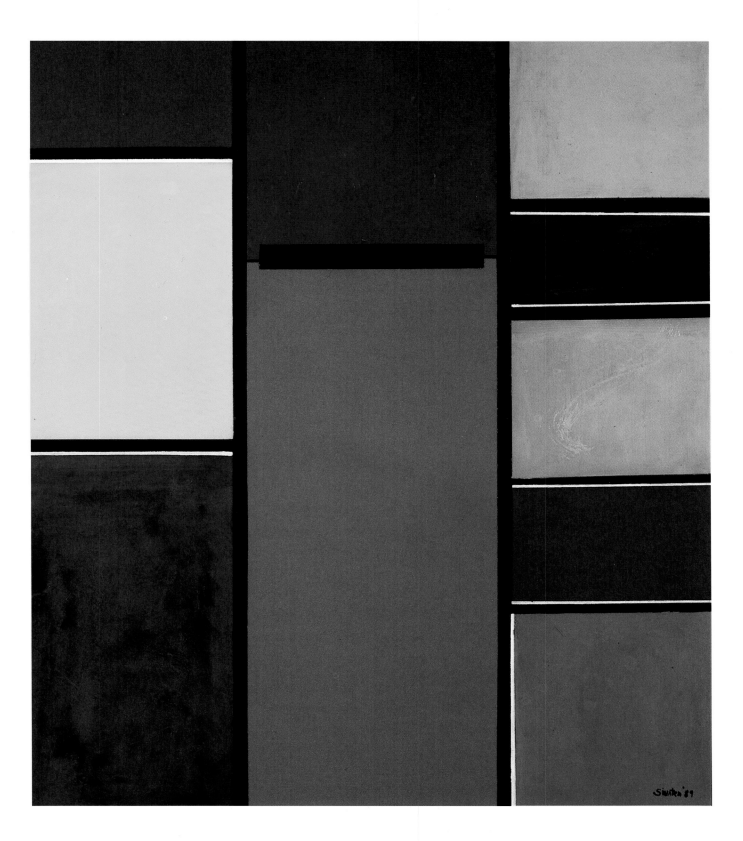

Collection of Nancy Sinatra, Jr.

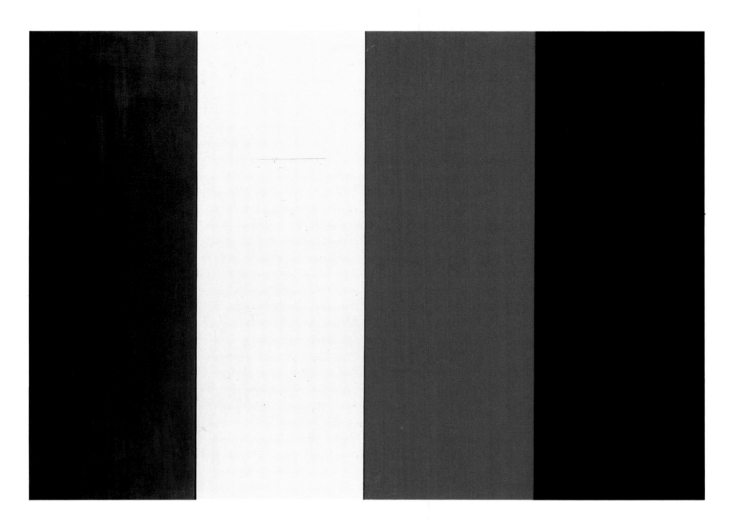

1971, 9″ × 12″, collection of Tina Sinatra

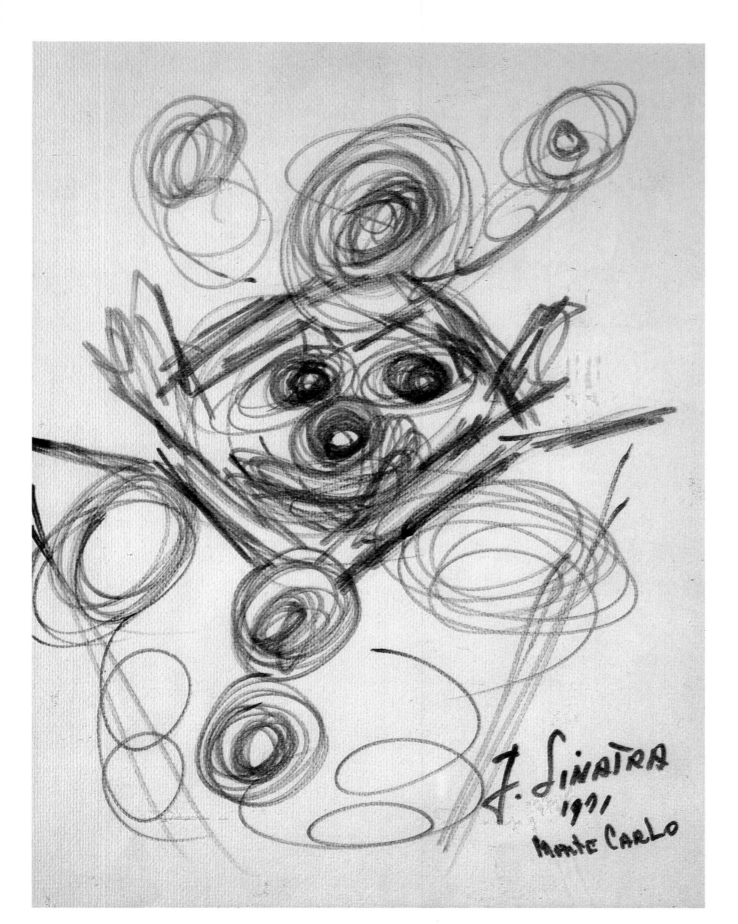

F. Sinatra
1971
Monte Carlo

1986, 50″ × 60″, the Desert Hospital, Palm Springs, California

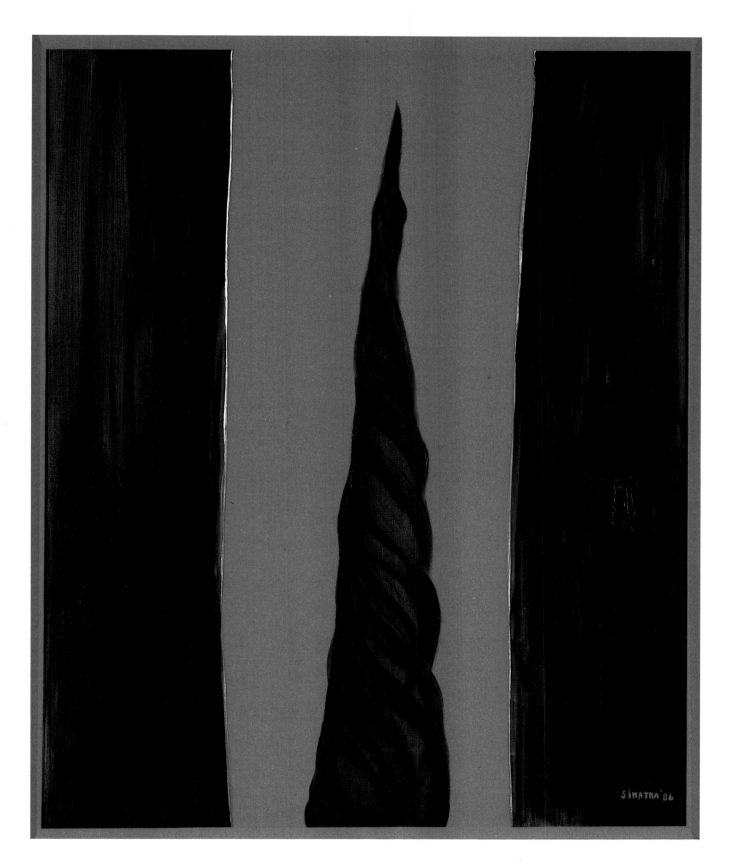

The Desert Hospital, Palm Springs, California

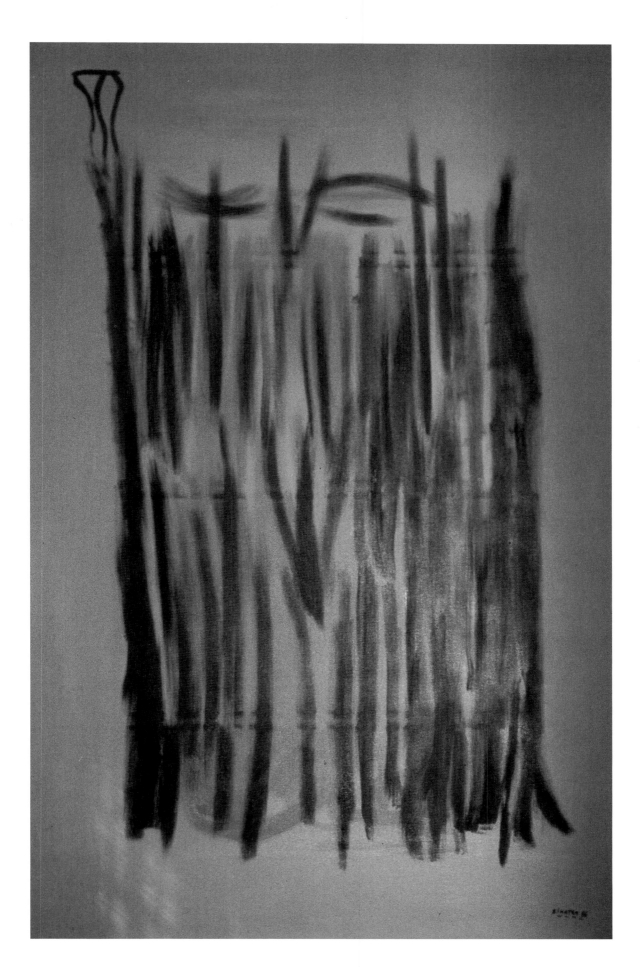

1986, 37″ × 55″, collection of Frank Sinatra

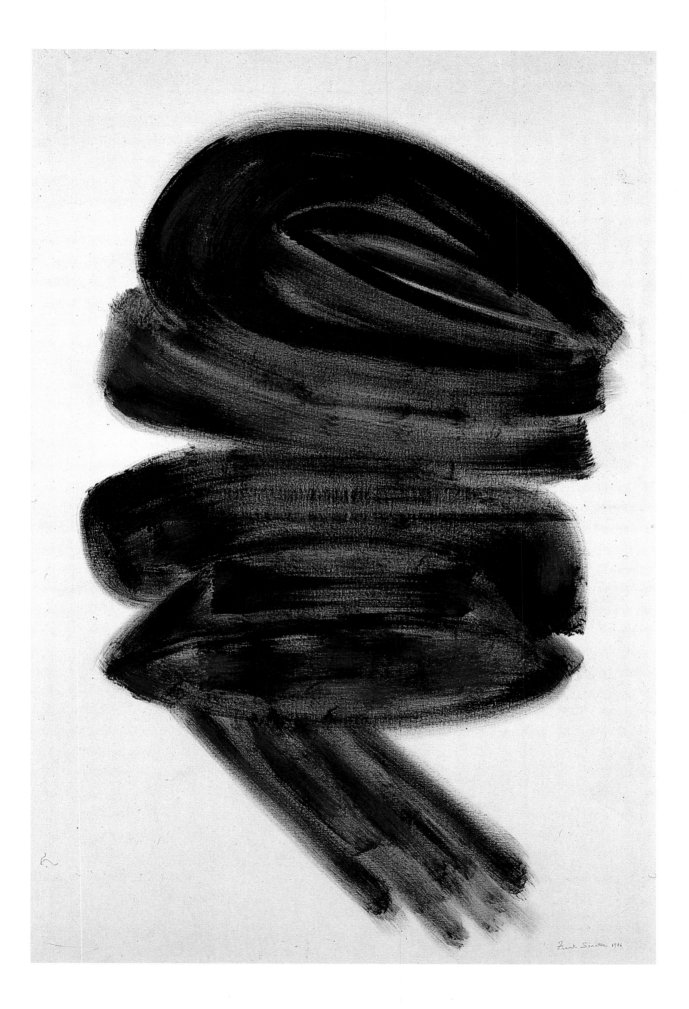

30″ × 36″, collection of Frank Sinatra

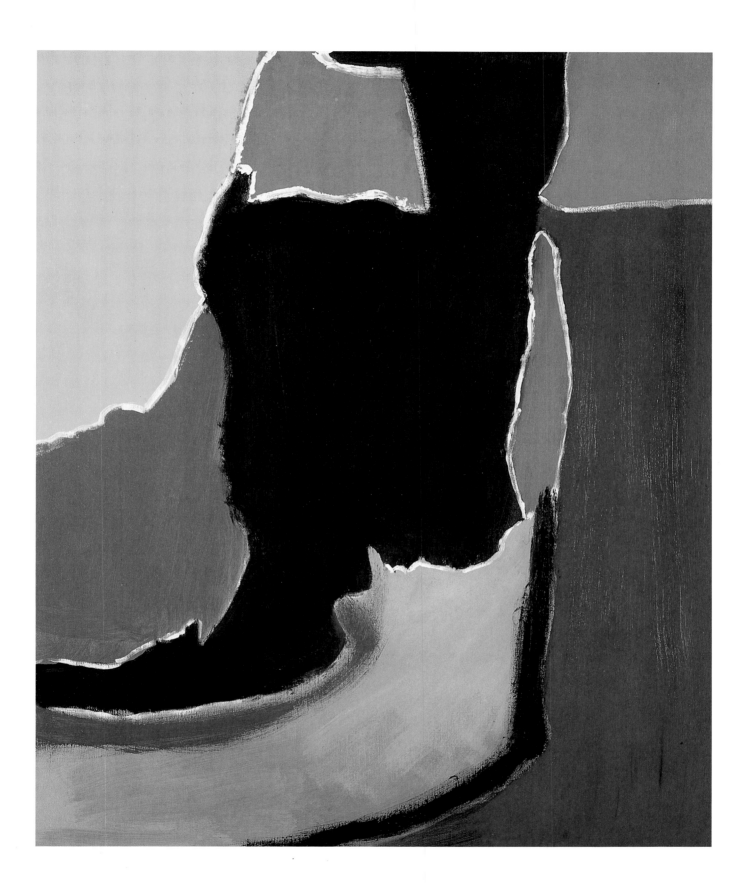

1986, 30″ × 40″, collection of N. V. Williams

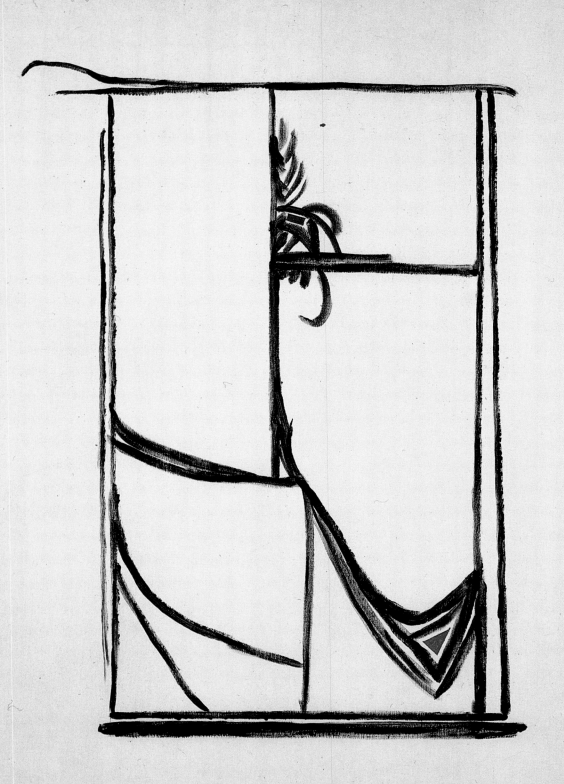

Sinatra 1986

1987, 31″ × 37″, collection of Frank Sinatra

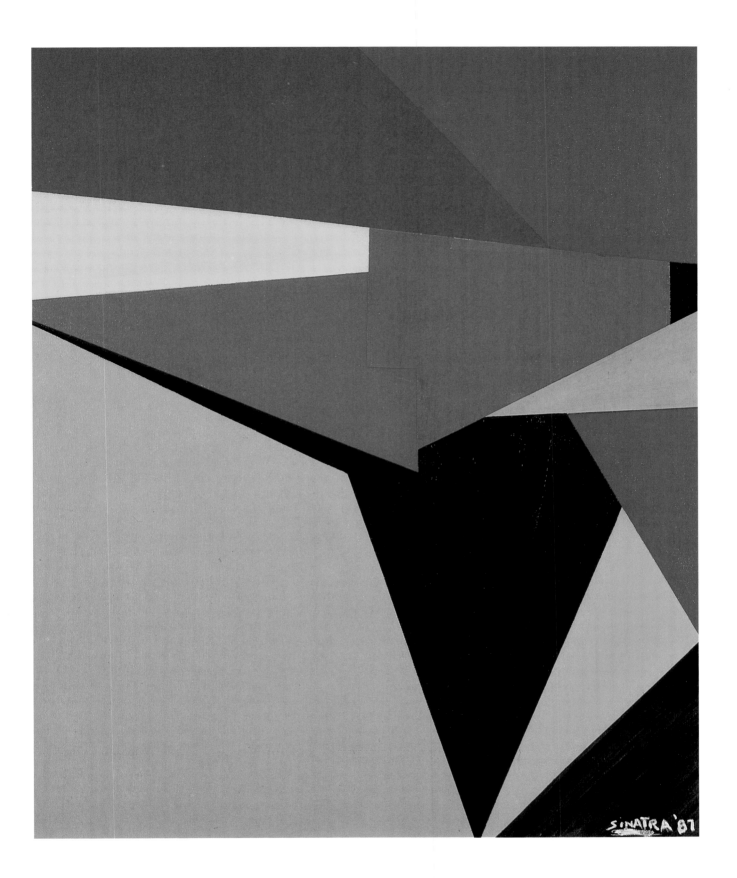

1986, 28″ × 38″, collection of Frank Sinatra

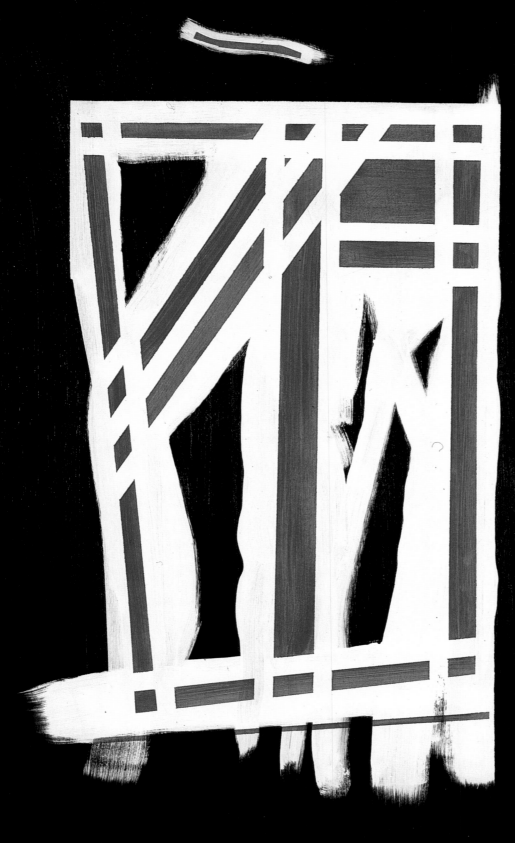

1984, 29″ × 39″, the Desert Hospital, Palm Springs, California

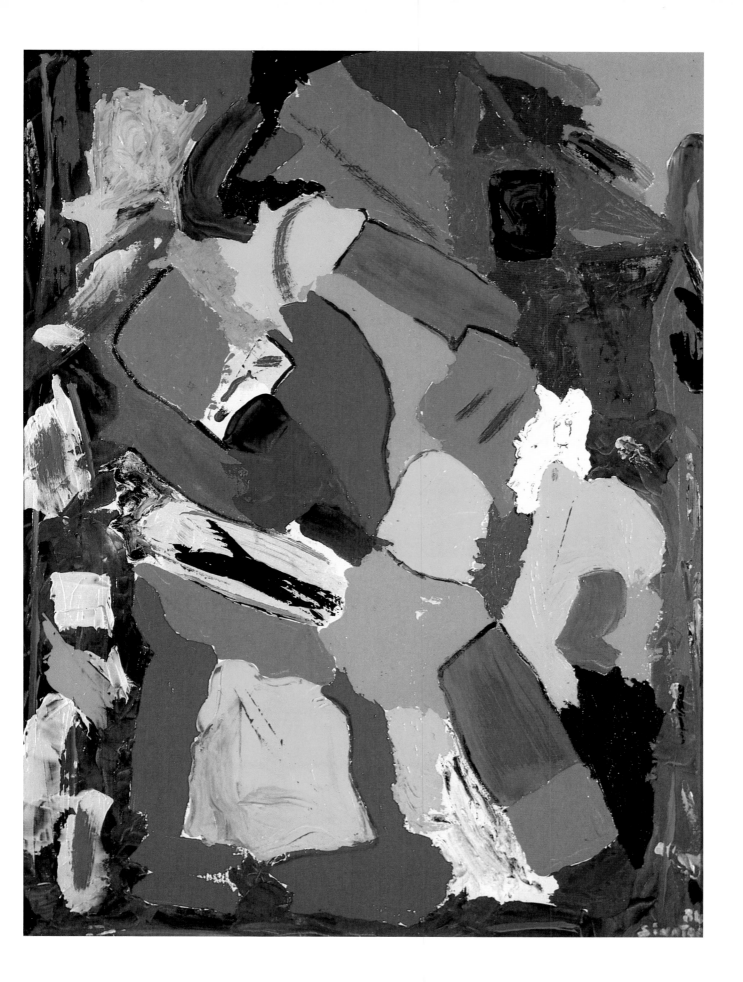

1985, 19″ × 23″, collection of Joy Derdiger

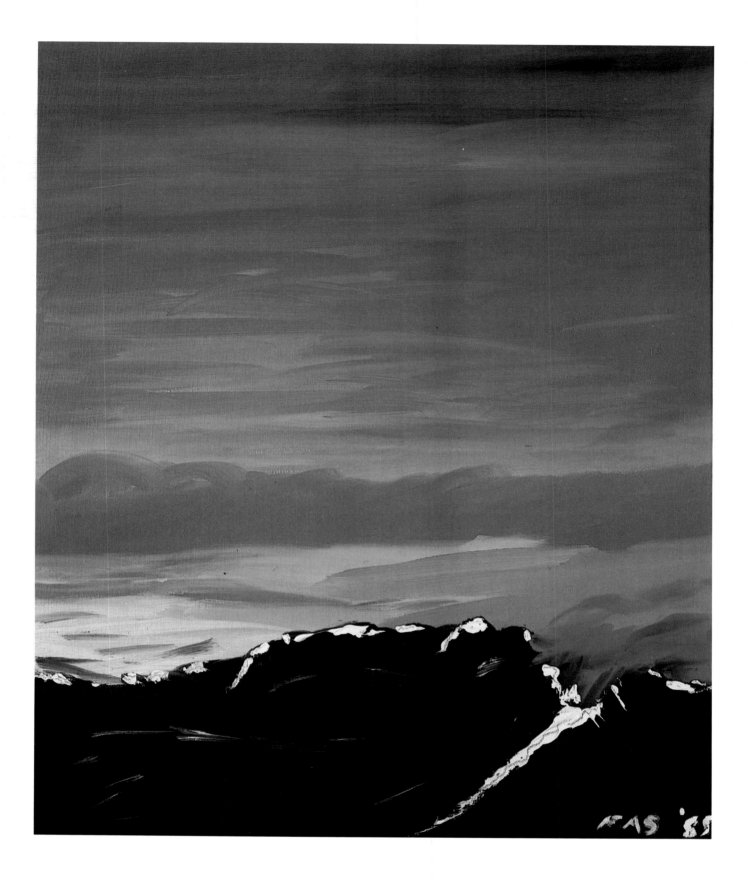

1987, 30″ × 34″, collection of Daniel Schwartz

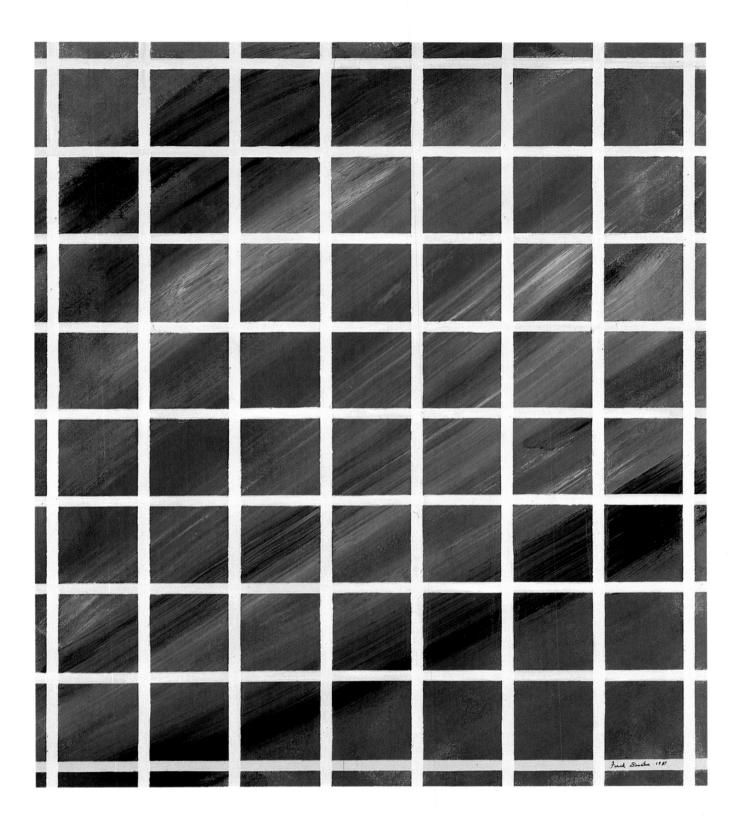

1986, 23″ × 47″, collection of Edward Fitzsimmons

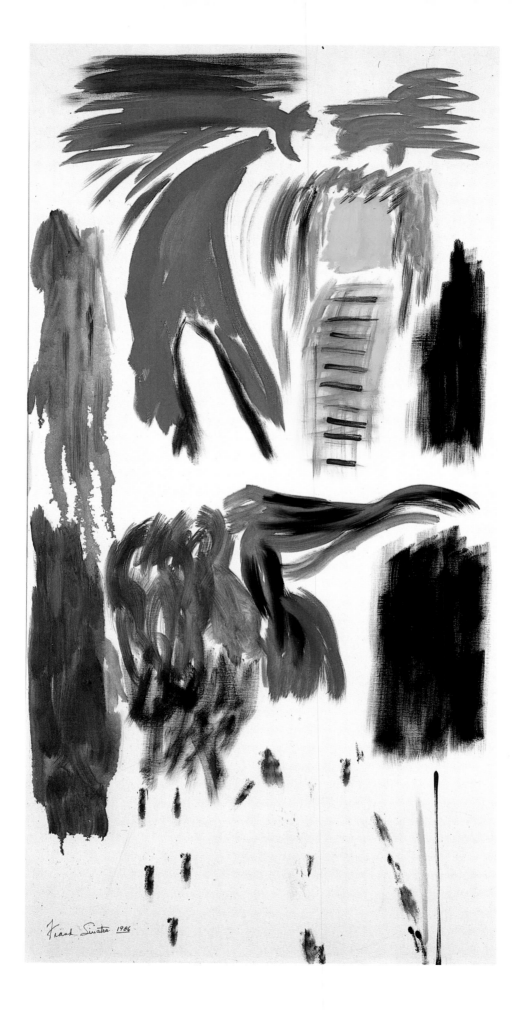

Frank Sinatra 1986

1987, collection of Nancy Sinatra, Jr.

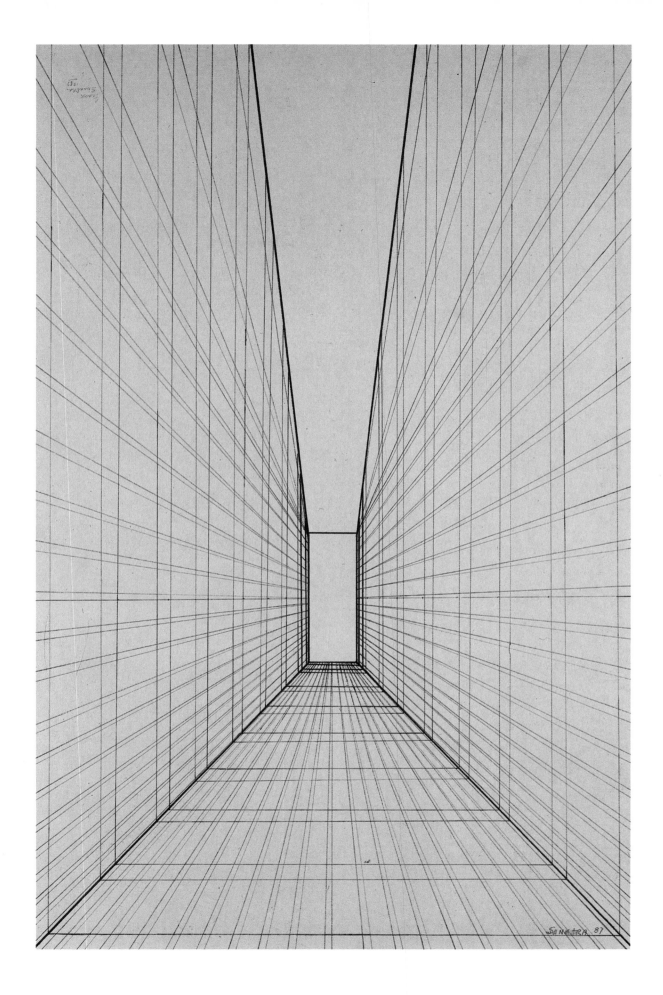

1987, 30″ × 20″, collection of Frank Sinatra

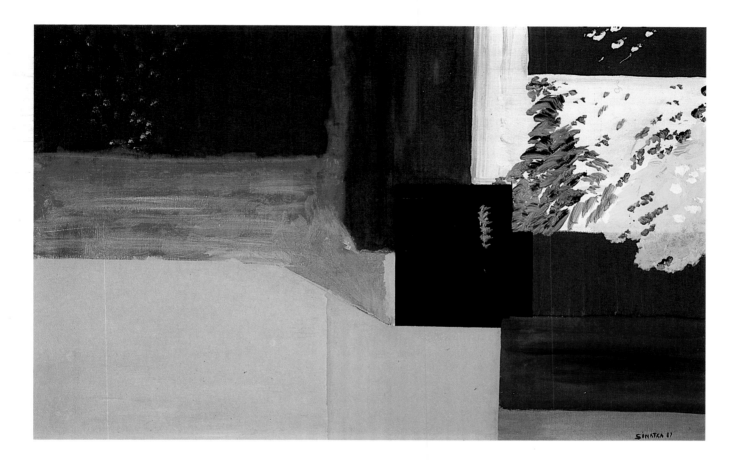

1989, 39″ × 39″, collection of Frank Sinatra

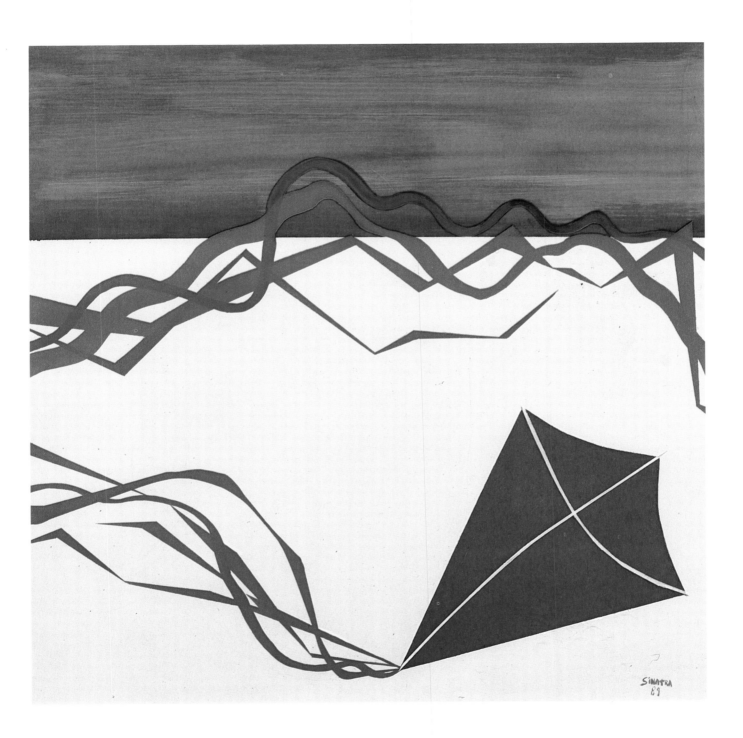

1987, 31″ × 36″, collection of Frank Sinatra

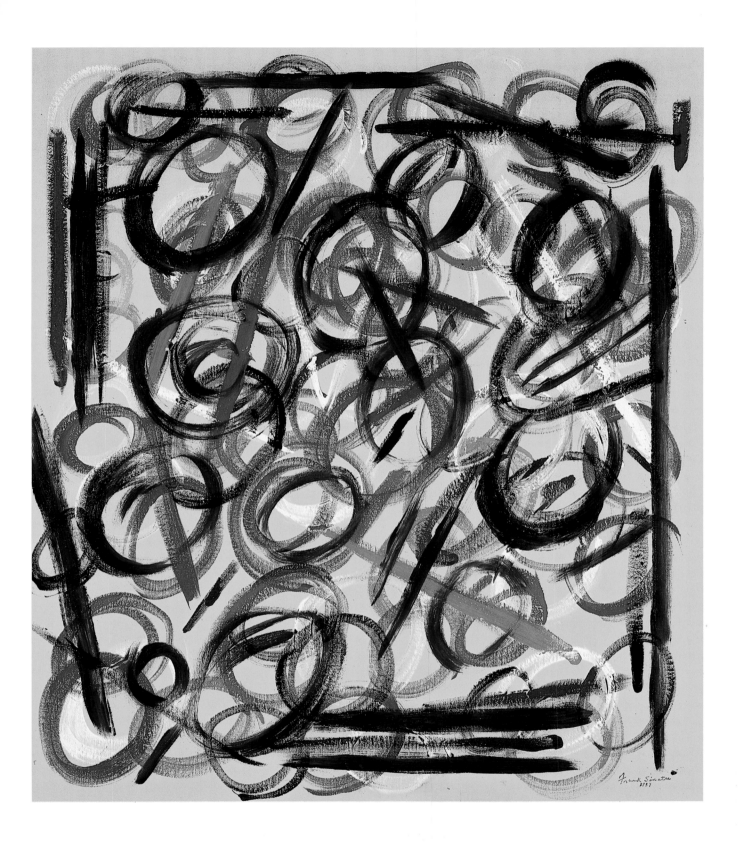

1987, 60″ × 48″, collection of Frank Sinatra

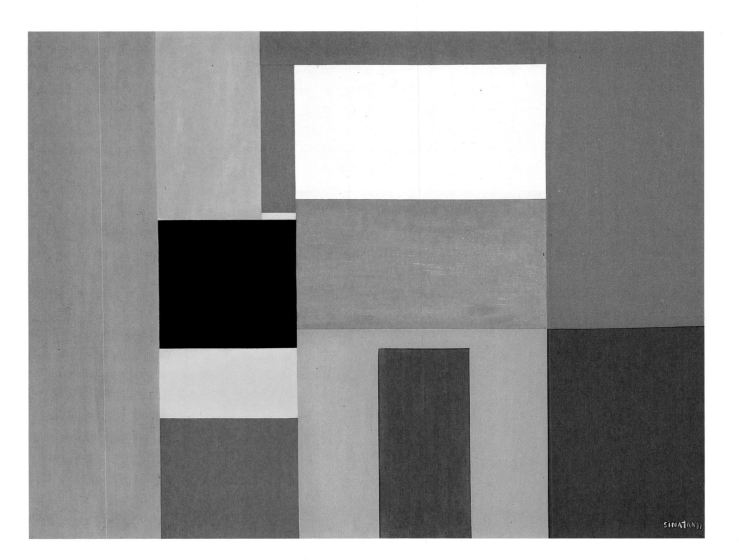

DATE DUE

HIGHSMITH